Brooklyn

THE BROOKLYN DAILY EAGLE
POSTCARDS 1905–1907

POSTCARD HISTORY SERIES

Brooklyn

THE BROOKLYN DAILY EAGLE POSTCARDS 1905–1907

Richard L. Dutton

ARCADIA

Copyright © 2004 by Richard L. Dutton
ISBN 0-7385-3531-1

First published 2004

Published by Arcadia Publishing,
an imprint of Tempus Publishing Inc.
Portsmouth NH, Charleston SC, Chicago,
San Francisco

Printed in Great Britain

Library of Congress Catalog Card Number: 2003116546

For all general information, contact Arcadia Publishing:
Telephone 843-853-2070
Fax 843-853-0044
E-mail sales@arcadiapublishing.com
For customer service and orders:
Toll-free 1-888-313-2665

Visit us on the Internet at www.arcadiapublishing.com

CONTENTS

PREFACE

This book is dedicated to my late father, Aubrey Whiteley Dutton, who lived in the Flatbush section of Brooklyn for more than 80 years and whose love for Brooklyn was part of his contagious enthusiasm about life in general.

When I was a little boy, I idolized him. He was a kind, gentle, eternally cheerful man with a great sense of humor, and was totally devoted to our family. He was also an artist and cartoonist and a graduate of Pratt Institute, which made him different from other fathers in our neighborhood. When we would go out walking together, he would always point out interesting architectural details to me, such as a house that was especially unchanged from an earlier era, a surviving porcelain street sign on the side of an old building, or exceptionally well-preserved ornamental cast-iron railings on a brownstone stoop. As a result, I have been enthusiastic about old Brooklyn myself for as long as I can remember.

When I was about 11, I came across a book that fascinated me in the Brooklyn Collection at the main branch of the Brooklyn Public Library at Grand Army Plaza. It was titled *Souvenir of our Public Schools, Brooklyn, New York*, and had been published in 1892. It contained large, clear, detailed, glossy photographs, one to a page, of each of the 85 Brooklyn public schools in existence at that time, along with a cameo-shaped photograph of the principal—typically a stern-looking Victorian gentleman with pince-nez and side whiskers—and a list of names of all of the teachers. I decided that I wanted to visit the site of each of these schools and take my own pictures of all of them that were still standing.

My father gladly became my companion on a series of jaunts through Brooklyn to do this. I would plan an itinerary of maybe 8 or 10 schools spread out all over the borough and figure out how we would get around using the bus, subway, or elevated train (we had no car), and, usually on a cold, crystal-clear morning with a brilliant blue sky, we would head out together. Halfway through the day, we would always stop at some special Brooklyn spot for a bite: a bowl of piping-hot soup in a luncheonette on Van Brunt Street in Red Hook, or a glistening knockwurst at the big cafeteria at Williamsburg Bridge Plaza, or a knish slathered with mustard at a deli in Brownsville. He also would sometimes take me to the used bookstores that were clustered around 4th Avenue and Broadway, just south of 14th Street in Manhattan, and we would search for old books relating to Brooklyn's past. By the time I was in my early teens, I already had a large collection of them.

Largely because of all the attention and encouragement I was given at home (my mother, a mathematics teacher at Erasmus Hall High School, was an equally devoted parent), I was always very successful in school, and I went to Yale on a scholarship when I was 16. When I was a sophomore, I won the college's Adrian Van Sinderen Book Collecting Prize for my collection of books on the history of Brooklyn (Van Sinderen, who had endowed the prize, was, coincidentally, another Brooklyn boy who had gone to Yale). The prize was presented to me by author John Hersey, which was quite a thrill.

Years later, after I had completed my education and returned to Brooklyn, my father, by then in his 70s, told me that an elderly friend of his had a large number of *Brooklyn Daily Eagle* postcards and asked if I would be interested in them if he could get them for me. I had already collected a few dozen of the cards over the years but had never come across them in any quantity;

so of course I said that I would love to have them. The next time I saw him, he handed me an old cigar box that his friend had covered with black contact paper, containing more than 400 *Eagle* postcards, all different, in clean, unused condition, and probably treasured by his friend from the time that they were new. Since then I have located additional cards here and there to fill in the gaps, and currently have all but 11 of the 486 cards that were issued.

So, with thanks to my father, I can say that all of the postcards reproduced in this book are from my personal collection, and essentially all of the research for this book was performed using my own library. As such, any errors are my own.

INTRODUCTION

Between 1905 and 1907, the *Brooklyn Daily Eagle,* Brooklyn's leading newspaper, issued a remarkable series of 486 black-and-white postcards, nearly all of them with photographs of Brooklyn scenes. Together, these cards provide a unique and detailed picture of what Brooklyn was like at that time. More than two hundred of the cards have been selected for reproduction in this book to take the reader on a tour of the borough as it was in the early years of the last century.

In 1905, Brooklyn was already a major urban center, with a population of more than 1.3 million. Until it had become a borough of New York City by merger seven years earlier, it had been the fourth-largest city in the United States. It had enormous manufacturing plants, including an architectural iron works, the world's largest clock factory, and sprawling sugar refineries; multi-story office buildings; imposing banks; scores of public schools; grand religious edifices on nearly every corner; elaborate mansions owned by captains of industry; and neighborhood upon neighborhood of the attractive and well-kept homes of the middle class. It also had a very large number of poor and unfortunate residents, such as the men who worked in the public wood yards, the slum boys who took advantage of the floating public baths along the waterfront, and the inmates of Raymond Street Jail and any number of charitable institutions that served the sick, the elderly, the orphaned, and the destitute. Social clubs and fraternal organizations played a much more important role in daily life in the era before motion pictures and television, and a number of capacious theaters presented live entertainment for admission prices as low as 15¢. There were three racetracks; a baseball park; country clubs that offered riding, golf, and boating; hundreds of acres of beautifully landscaped public parks containing busts and statues of heroes of the past; and the beaches, hotels, and amusement attractions at Coney Island. All of this is captured in the *Eagle* postcards.

In 1905, Republican Theodore Roosevelt began his second term as president of the United States, having taken office upon Pres. William McKinley's assassination in 1901. In the 1904 election, he had carried Brooklyn by a small margin, receiving his strongest support in the more affluent sections. He visited Brooklyn in May 1905, making a stop at the Union League Club, a Republican stronghold. In that era, New York's two U.S. senators, along with a majority of Brooklyn's U.S. congressmen and New York state senators and assemblymen, were Republicans.

The population of the borough was growing rapidly in the first decade of the 20th century, and it was a time of large-scale public school construction. Although a number of low-rise red brick schoolhouses dating, in some cases, from the 1860s and earlier, were still in use, the new schools were generally tall, massive, box-like brick-and-limestone buildings that in some cases could accommodate more than 4,000 students. It was also an era of extensive library construction, as new public libraries, funded by philanthropist Andrew Carnegie, opened all over Brooklyn beginning in 1904. The Carnegie libraries were modern, well designed, well equipped, and even luxurious, and the opening of each new branch was a major news event in the borough.

Twenty years after the completion of the Brooklyn Bridge, the Williamsburg Bridge opened in 1903, and plans began immediately for another bridge connecting Brooklyn and Manhattan. Known as East River Bridge No. 3, it would ultimately be called the Manhattan Bridge. The Brooklyn Museum and the Long Island Railroad Terminal were also under construction, and

plans were being made for a new Academy of Music to replace the one in Brooklyn Heights that was destroyed by fire in 1903.

For many decades, Brooklyn was known first as "the city of churches," and beginning in 1898, as "the borough of churches," so it is not surprising that churches and synagogues appear on many of the *Eagle* postcards. In 1905, the number of Roman Catholic parishioners in Brooklyn— nearly 370,000—greatly exceeded the combined membership of all Protestant churches in the borough, reflecting Brooklyn's large Irish population and growing Italian population. Of the Protestant denominations, Episcopalians were the most numerous, with 30,783 members. Lutherans were second with 23,704 members, many of them German-speaking (although some Germans were Catholic). Methodists (23,644) and Baptists (18,640) ranked third and fourth, respectively, followed by Presbyterians (17,805) and Congregationalists (15,651). The membership of Brooklyn's synagogues was small by comparison but growing rapidly as Jews moved into the borough in large numbers. The borough's African American population in 1905 was about 20,000, many of whom lived along Fulton Street and Atlantic Avenue east of Bedford Avenue. A number of the churches they established still exist today.

The *Eagle* was founded in 1841 (one of its early editors was the poet Walt Whitman) and by 1905 had been the borough's favorite daily newspaper for many years. It occupied its own newly renovated eight-story building a block north of borough hall, operated its own information bureau, and gave its own cups and trophies for athletic events such as bowling, billiards, model yachting, and riflery. It also published the Eagle Library of books and pamphlets on a variety of subjects, including guidebooks to places as far flung as Washington, D.C., and Paris (where it had an office) and its annual almanac, each issue of which was an immensely detailed compendium of information of all sorts, especially with regard to Brooklyn.

In November 1905, the *Eagle* began issuing, at a rate of six per week, its Brooklyn picture postcards. The cards were numbered consecutively, and every card also had a series number, with each week's group of six cards making up a separate series. The final series, numbered 81 and consisting of cards numbered 481–486, appeared in May 1907.

One
LANDMARKS

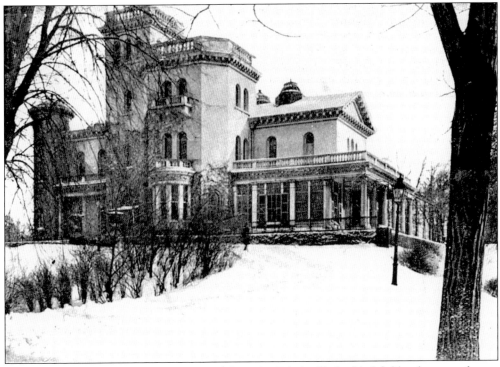

The former home of railroad magnate and financier Edwin Clarke Litchfield, who owned most of the land that makes up present-day Park Slope, faces Prospect Park West between Fourth and Fifth Streets. It is in the style of an Italian country villa and was designed by Alexander Jackson Davis, perhaps the greatest American architect of his day. It dates from 1857. Before the blocks of homes on the upper part of Park Slope were built, it had a view down the hill to the harbor. The property was acquired from Litchfield for inclusion in Prospect Park, and for many years has been used as an administrative office by the parks department.

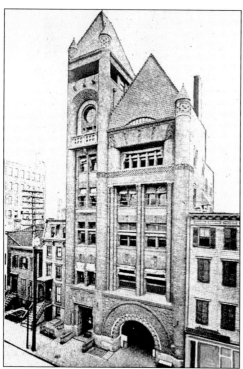

The stone, brick, and terra-cotta Brooklyn Fire Headquarters, which still stands on the east side of Jay Street between Myrtle Avenue and Willoughby Street in the borough hall area, dates from 1892. It was designed by Brooklyn architect Frank Freeman, whose Romanesque Revival buildings, like this one, have been compared to those of the great exponent of the style, H. H. Richardson.

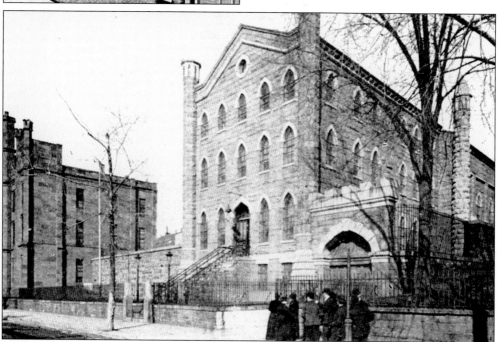

In 1905, those who were arrested in Brooklyn were likely to be locked up in Raymond Street Jail, which faced on the east side of Raymond Street south of Willoughby Street, just west of Fort Greene Park. On October 1, 1904, the use of striped suits for inmates of all penal institutions was discontinued. Raymond Street no longer exists; from Hanson Place north, it is now called Ashland Place. The site of the jail is now occupied by Brooklyn Hospital buildings.

The Temple Bar Building (44 Court Street), on the northwest corner of Court and Joralemon Streets, was only four years old in 1905. With 12 stories, it was Brooklyn's leading "skyscraper." It was designed by prolific Brooklyn architect George L. Morse and remains one of the major office buildings of the borough hall area today.

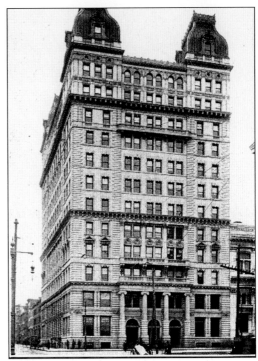

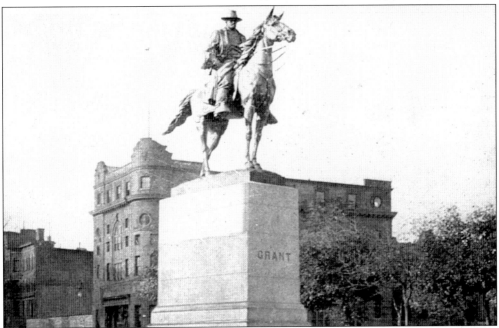

This equestrian statue of Gen. Ulysses S. Grant at Grant Square was unveiled on April 25, 1896. It was given to what was then the city of Brooklyn by the Union League Club, a social club founded in 1889. (Two of Brooklyn's other major clubs, the Montauk Club and the Midwood Club, were also founded the same year.) The Union League clubhouse, a mansion on the southeast corner of Bedford Avenue and Dean Street, looked out onto the statue. The building is still standing and is now used as a senior center.

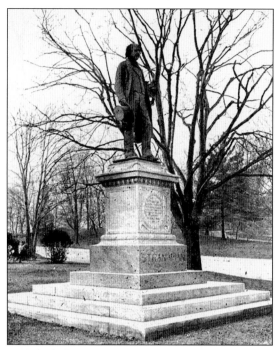

James S. T. Stranahan was a transportation magnate who, as president of the Brooklyn Park Board, was responsible for the creation of Prospect Park. He worked closely with its designers, Frederick Law Olmsted and Calvert Vaux. Stranahan was present when this statue of him in the park was dedicated on June 6, 1891. Its sculptor, Brooklyn native Frederick MacMonnies, later designed and executed the figural sculpture on the nearby Soldiers' and Sailors' Memorial Arch.

The Cemetery of the Evergreens, which opened in 1851, occupies more than 300 acres at the southeast corner of the Bushwick section, partly in Brooklyn and partly in Queens. This building still stands on the hill inside the cemetery entrance at Bushwick Avenue and Conway Street. Rev. John D. Wells of the South Third Street Presbyterian Church was instrumental in bringing thousands of evergreen trees from upstate New York to plant at the cemetery.

This bronze statue of Abraham Lincoln in Prospect Park is the work of Henry Kirke Brown, whose other works include a similar statue of Lincoln and an equestrian statue of George Washington, both in Union Square, Manhattan. The Prospect Park statue of Lincoln dates from 1869; formerly, it stood at Grand Army Plaza. On July 30, 1903, it was blown from its pedestal and broken during a severe lightning storm. It was reconstructed and still stands today.

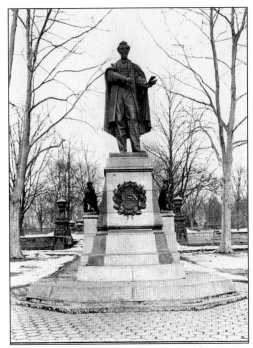

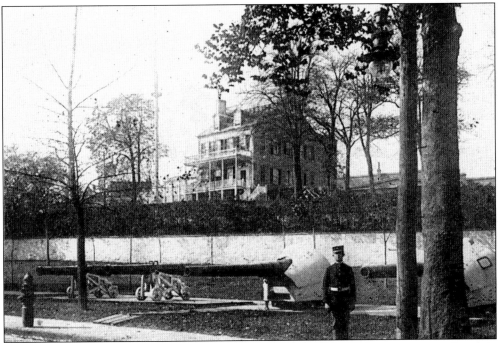

This view inside the Brooklyn Navy Yard (New York Naval Shipyard) shows captured guns in the foreground and the wood-frame, Federal-style commandant's residence, which dates from 1806, on a rise in the distance. The navy yard was established in 1801 and played an important role in the building and repairing of ships through all of the wars in which this country participated until it was finally closed in 1966. In 1905, it was open to the public for viewing daily from nine to five. It is now an industrial park.

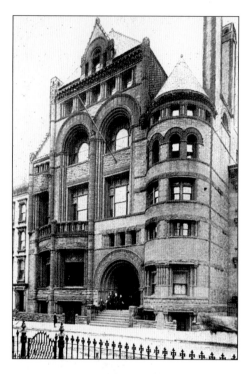

The Kings County Democratic Club was founded in 1904 and met in this building, located on the south side of Schermerhorn Street between Smith Street and Boerum Place. It was also the home of the Germania Club, a German social and cultural organization that was founded in 1860; the club had 250 members in 1905. The building was another gem of Romanesque Revival architecture designed by Frank Freeman and dated from *c.* 1890. The site is now occupied by the Central Court building.

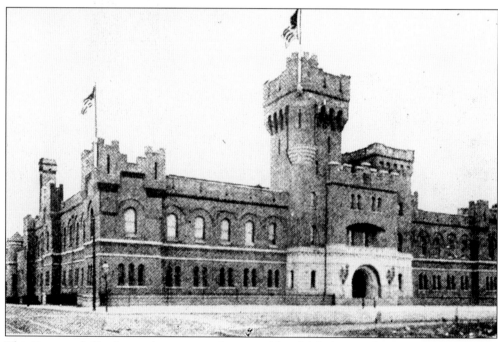

The Fourteenth Regiment Armory, on the west side of 8th Avenue between 14th and 15th Streets, was home to an infantry unit that saw extensive action during the Civil War and, like Brooklyn's other National Guard units, was called up to quell violence during the Brooklyn motormen's strike in 1895. This massive, castle-like brick structure is, like other New York City armories, now used to house the homeless.

In 1905, the granite Romanesque Revival–style
Federal Building, on the northeast corner of
Washington and Johnson Streets, just north of
borough hall, housed Brooklyn's main post office, as
well as federal offices and courts. The building was
completed in 1891 and remains in use today.

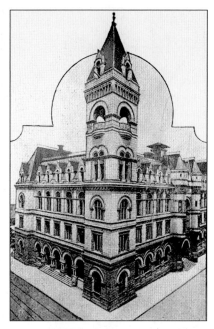

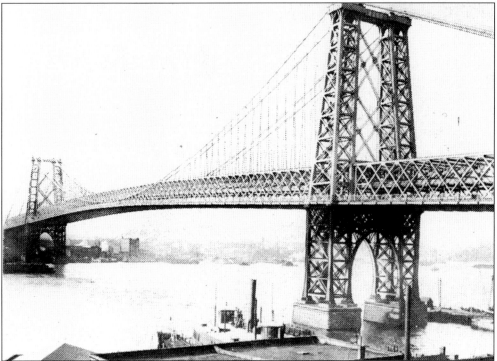

For more than 20 years after its opening in 1883, the Brooklyn Bridge was the only bridge
connecting Brooklyn to Manhattan. The second bridge to be completed was the slightly longer
Williamsburg Bridge, or "new Eastern District Bridge," which connected a totally different part
of Manhattan (the teeming tenement district of the Lower East Side) to a totally different part of
Brooklyn (the heart of what had been, until 1855, the separate city of Williamsburgh). The
opening ceremonies for the bridge were held on December 19, 1903.

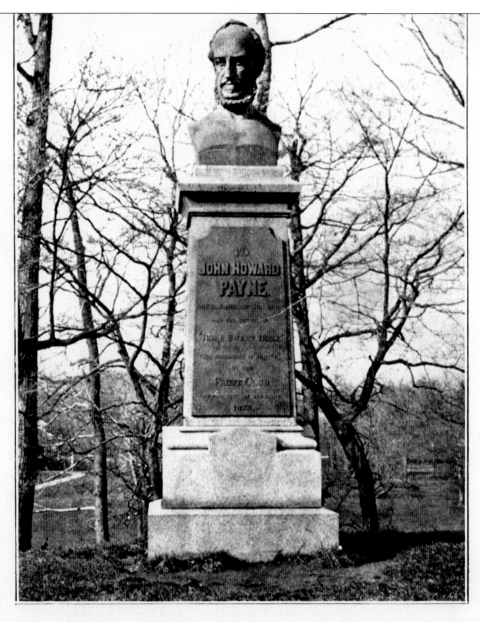

STATUE OF JOHN HOWARD PAYNE, IN THE FLOWER GARDEN, PROSPECT PARK.

Prospect Park contains busts and statues of a number of musical figures of the past, ranging from classical composers such as Mozart and Beethoven to songwriters such as John Howard Payne. Payne is now remembered for just one song, "Home, Sweet Home," which remained popular long after his death in 1852 and would have been familiar to virtually every American in 1905. The Payne sculpture, dating from 1873, is by Henry Baerer. It was placed in the park by the Faust Club of Brooklyn, an organization of journalists, artists, actors, and musicians.

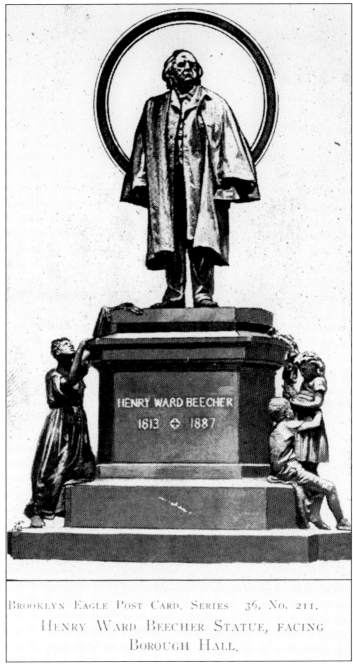

This statue of noted Brooklyn pastor Henry Ward Beecher, which stands in Cadman Plaza north of borough hall, was unveiled in 1891, four years after Beecher's death. It is the work of sculptor John Quincy Adams Ward, who was born in Ohio and came to Brooklyn to serve as an apprentice to Henry Kirke Brown, the sculptor of the Abraham Lincoln statue in Prospect Park. The base of the Beecher statue, depicting an African American woman at the left (because of Beecher's accomplishments as an abolitionist) and a boy and girl at the right (because of his work with children), is by Richard Morris Hunt, who also designed the base of the Statue of Liberty.

19

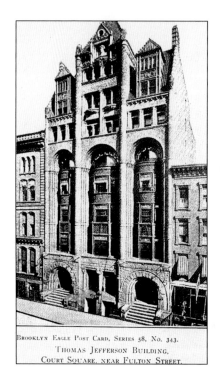

This handsome brown sandstone building of the Thomas Jefferson Association, the headquarters of Brooklyn's Democratic General Committee, was yet another Romanesque Revival building in the downtown area designed by Brooklyn architect Frank Freeman. It dated from *c.* 1890 and stood on Court Square, a street that ran for one block along the east side of the municipal buildings that formerly stood behind borough hall. Note the large bust of Thomas Jefferson at the top of the facade.

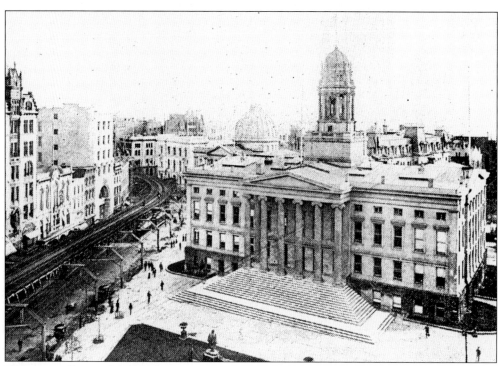

This view of borough hall before the construction of the tall municipal building behind it shows the Fulton Street elevated train line to the left and the Henry Ward Beecher statue in the foreground, where it was located before the creation of Cadman Plaza.

The interesting Romanesque Revival–style Franklin Trust Company building (164 Montague Street), on the southwest corner of Clinton and Montague Streets in Brooklyn Heights, is another office building designed by Brooklyn architect George L. Morse. A variety of stone, brick, and terra-cotta textures were employed in its construction. It is still in use today.

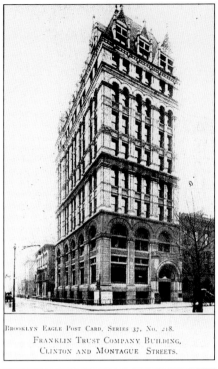

BROOKLYN EAGLE POST CARD, SERIES 37, NO. 218.
FRANKLIN TRUST COMPANY BUILDING,
CLINTON AND MONTAGUE STREETS.

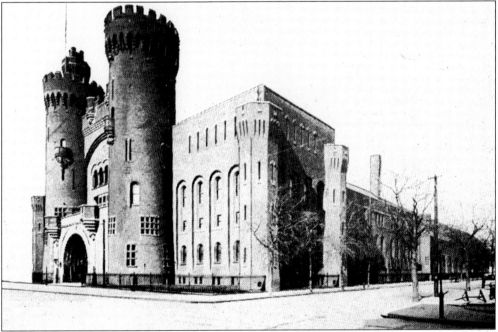

The 13th Regiment Armory of the New York National Guard, on the east side of Sumner Avenue (now Marcus Garvey Boulevard) between Jefferson and Putnam Avenues in Bedford-Stuyvesant, is a huge, castle-like structure that dates from 1894. Its troops had been called up during the Brooklyn motormen's strike in 1895 and had also furnished volunteers three years later during the Spanish-American War.

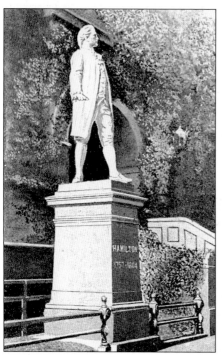

This bronze statue of Alexander Hamilton by William Ordway Partridge formerly stood at the entrance to the Hamilton Club, at the southwest corner of Clinton and Remsen Streets in Brooklyn Heights. Partridge was also the sculptor of the equestrian statue of Ulysses S. Grant at Grant Square. The Hamilton Club was founded in 1882, and in 1905 it had 653 members. The site of its clubhouse is now occupied by an apartment building. The Hamilton statue was moved in 1936 to Hamilton Grange, Hamilton's former residence in Manhattan.

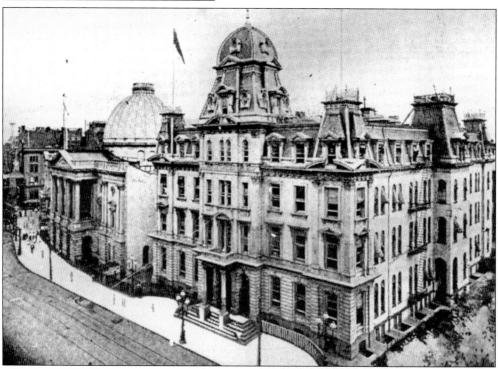

The marble, domed, mansard-roofed municipal building dated from 1876 and stood on the south side of Joralemon Street between Court Street and Fulton Street, behind and slightly to the east of borough hall. It was replaced by the 13-story municipal building with a cornerstone dated 1924, which still stands at the southeast corner of Court and Joralemon Streets.

In the concert grove in Prospect Park is a bust of Thomas Moore, the Irish poet whose *Irish Melodies,* containing settings of his romantic lyrics to traditional Irish harp tunes, was one of the most popular books in Irish American households in 1905. The Moore bust was presented to the park on the centenary of his birth in 1879 by the St. Patrick Society of Brooklyn. The sculptor of the bust was John G. Draddy, whose work also graces St. Patrick's Cathedral in Manhattan.

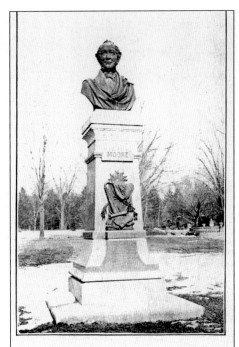

BROOKLYN EAGLE POST CARD, SERIES 6, No. 31.
BRONZE BUST OF THOMAS MOORE IN PROSPECT PARK.

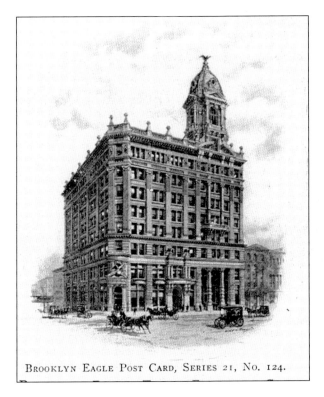

BROOKLYN EAGLE POST CARD, SERIES 21, No. 124.

The Brooklyn Daily Eagle building on the southeast corner of Washington and Johnson Streets, which dated from 1891, was substantially renovated just before this postcard was issued. Its architect was, once again, George L. Morse. A novel feature of the building was that the pressroom was visible to the public at street level.

23

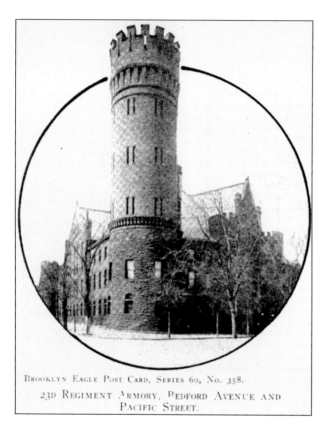

The 23rd Regiment Armory of the New York National Guard, on the west side of Bedford Avenue between Atlantic Avenue and Pacific Street in the Bedford-Stuyvesant section, is an enormous fortress with a corner tower more than 130 feet high. It dates from 1892.

BROOKLYN EAGLE POST CARD, SERIES 60, No. 358.
23D REGIMENT ARMORY, BEDFORD AVENUE AND PACIFIC STREET.

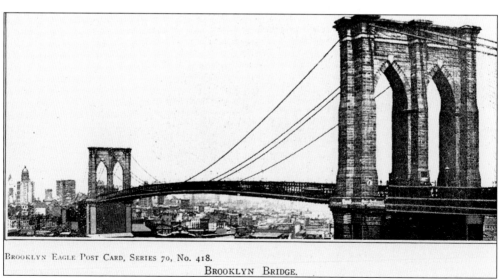

BROOKLYN EAGLE POST CARD, SERIES 70, No. 418.
BROOKLYN BRIDGE.

The Brooklyn Bridge, a majestic architectural and structural masterpiece, known worldwide and undoubtedly the most familiar symbol of Brooklyn, was opened on May 24, 1883. In 1905, it was a toll bridge, charging tolls of 3¢ for a single horse, 5¢ for a single-horse vehicle, and 10¢ for a two-horse vehicle or an automobile.

The 478-acre Green-Wood Cemetery, established in 1838, was a popular tourist attraction in 1905 because of its beautifully landscaped grounds overlooking New York Harbor. It was also known for its monuments (some quite elaborate) to notables, including inventors Samuel F. B. Morse (the telegraph), Elias Howe (the sewing machine), and Peter Cooper (the locomotive); newspaperman Horace Greeley; printmakers Nathaniel Currier and James Ives; furniture maker Duncan Phyfe; evangelist and hymn writer Ira D. Sankey; and many others.

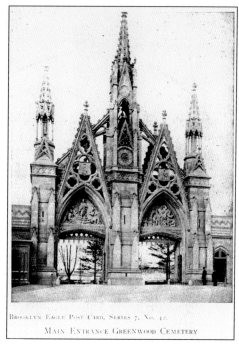

Brooklyn Eagle Post Card, Series 7, No. 42.

MAIN ENTRANCE GREENWOOD CEMETERY

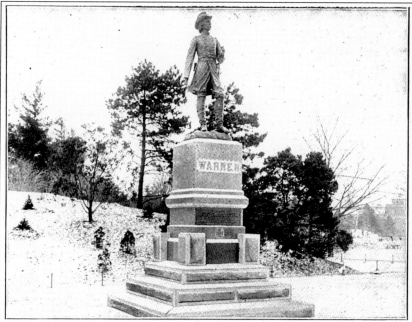

Brooklyn Eagle Post Card, Series 23, No. 136.

MONUMENT OF MAJOR-GENERAL GOUVERNEUR KEMBLE WARREN, FACING PROSPECT PARK.

This statue of Civil War hero Maj. Gen. Gouverneur Kemble Warren was dedicated on July 4, 1896, and stands in the raised, fenced park area on the northwest corner at the intersection of Flatbush Avenue and Prospect Park West. The sculptor, German-born Henry Baerer, also created two other sculptures in Prospect Park: the bust of Beethoven in the Concert Grove and the John Howard Payne monument.

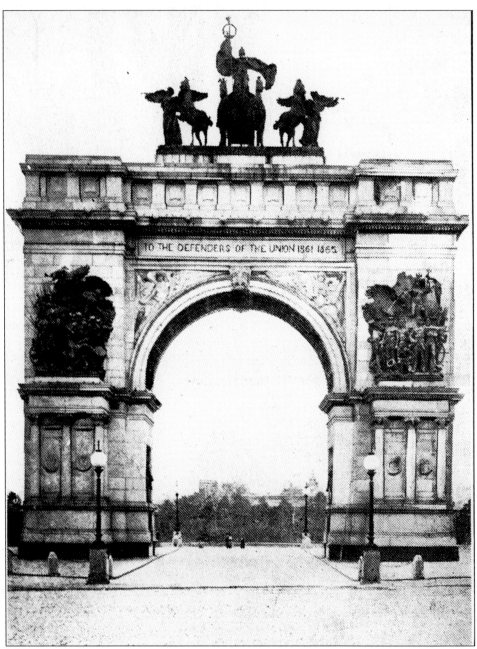

The Soldiers' and Sailors' Arch at Grand Army Plaza is a memorial to Union casualties of the Civil War. It was originally designed by Manhattan architect John Hemenway Duncan and was completed in 1892. It was subsequently modified by the famed Stanford White to include the platforms for its sculpture, which is the work of Frederick MacMonnies. MacMonnies was born in Bedford-Stuyvesant, worked with Augustus Saint Gaudens, studied in Paris, and became a protégé of White when he returned to New York. The figure on top of the arch is Columbia, the female symbol of the United States, in a four-horse chariot; the group on the left consists of army figures, and that on the right, of navy figures.

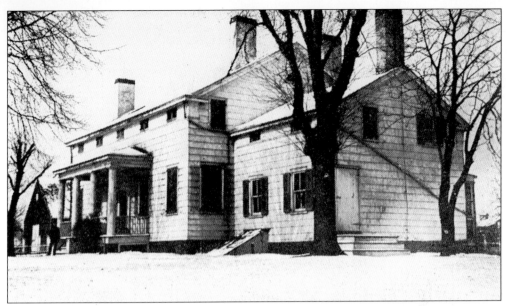

The Charles B. Vanderveer homestead was the farmhouse for a 70-acre farm at the foot of Pennsylvania Avenue in Canarsie, which had belonged to the Vanderveer family for many generations. The Red Mill shown below was also located on the property.

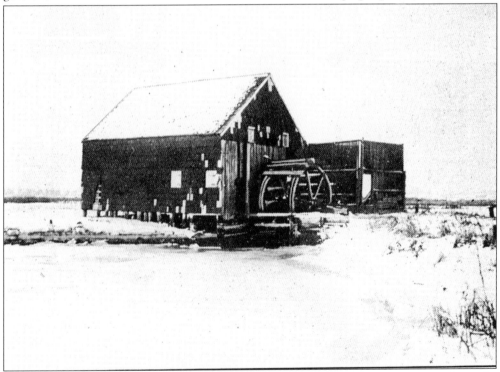

The Vanderveer Mill, also called the Red Mill, was located on Fresh Kill (Fresh Creek) in the vicinity of present-day Flatlands and Williams Avenues, and operated by the Vanderveer family as early as 1770. It was a curiosity at the turn of the last century because of its ancient-but-well-preserved wooden machinery. It was torn down shortly after this postcard was issued.

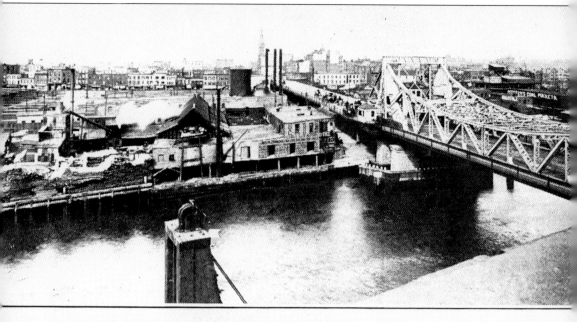

OOKLYN EAGLE POST CARD, SERIES 31, No. 181.

BASCULE BRIDGE OVER NEWTOWN CREEK.

The Newtown Creek Bridge, a bascule drawbridge that connected the northern end of Manhattan Avenue in Greenpoint with Vernon Avenue in Long Island City, Queens, was brand new when this photograph was taken. The bridge has since been replaced by the Pulaski Bridge several blocks to the east, which rises much higher above water level.

Two

COMMERCE

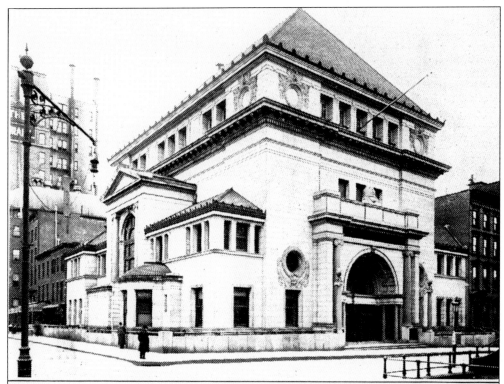

BROOKLYN EAGLE POST CARD, SERIES 4, No. 22.

BROOKLYN SAVINGS BANK BUILDING, CLINTON AND PIERREPONT STREETS

The Brooklyn Savings Bank's building on the northeast corner of Pierrepont and Clinton Streets in Brooklyn Heights dated from 1893 and was designed by architect Frank Freeman, himself a Heights resident. Several of Freeman's Romanesque Revival buildings, such as the Brooklyn Fire Headquarters on Jay Street, were noted in the previous chapter. He also designed the classical Crescent Athletic Club (see page 89), right across the street from the site of the Brooklyn Savings Bank, and the Romanesque Revival-style Eagle Warehouse & Storage Company building (see page 34). The site of the bank is now occupied by a modern high-rise office building.

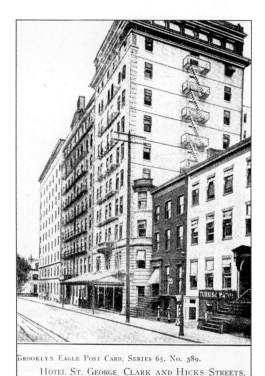

In 1905, the St. George, on Clark Street in Brooklyn Heights, was one of the largest hotels in the country. It advertised that it was closer to Wall Street than the Midtown Manhattan hotels and offered a sun parlor and roof garden with a view of the harbor, a long-distance telephone in every room, and 375 private baths. It charged "$1 and up" on the European plan (no meals included).

BROOKLYN EAGLE POST CARD, SERIES 65, No. 389.
HOTEL ST. GEORGE, CLARK AND HICKS STREETS.

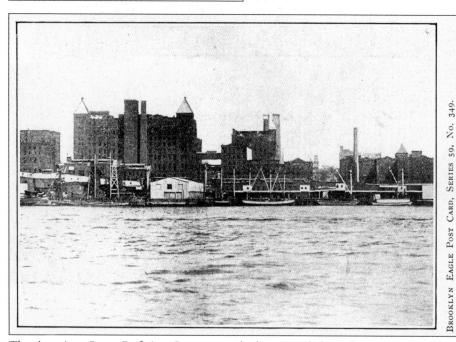

BROOKLYN EAGLE POST CARD, SERIES 59, No. 349. AMERICAN SUGAR REFINING COMPANY, EAST RIVER, KENT AVENUE, BETWEEN SOUTH FIRST AND SOUTH SECOND STREETS. THE LARGEST IN THE WORLD.

The American Sugar Refining Company, which operated this refinery between Kent Avenue and the East River from South First to South Fifth Streets in Williamsburg, resulted from the consolidation of several refineries and was also known as the "Sugar Trust." It was the largest refinery in the world and could produce 14,000 barrels of refined sugar per day. When it shut down on March 21, 1905, 2,000 men were temporarily put out of work.

The unusual Jenkins Trust Company building still stands at the southwest corner of Nostrand and Gates Avenues in Bedford-Stuyvesant. The upper floors of the building offered warehouse storage, and the bank operation was at ground level. The trust company's financial woes were reported at length in the *Brooklyn Daily Eagle* shortly after this postcard appeared.

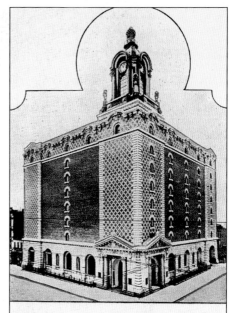

BROOKLYN EAGLE POST CARD, SERIES 24, No. 143. JENKINS TRUST COMPANY BUILDING, NOSTRAND AND GATES AVENUES.

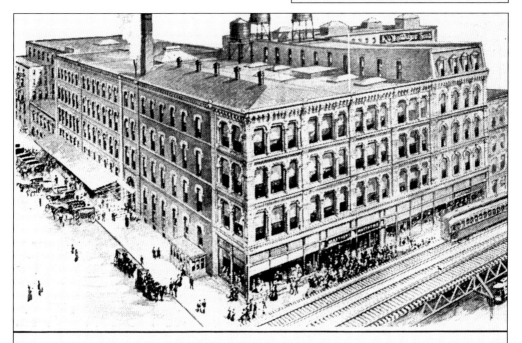

BROOKLYN EAGLE POST CARD, SERIES 74, No. 440.
A. D. MATTHEWS' SONS' DEPARTMENT STORE, FULTON STREET.

Although forgotten today, A. D. Matthews' Sons, on the south side of Fulton Street between Smith Street and Gallatin Place, was Brooklyn's oldest department store in 1905. Founded in the 1830s, it had to move from its previous location farther north on Main Street, in the older district closer to the river, as a result of the construction of the Brooklyn Bridge.

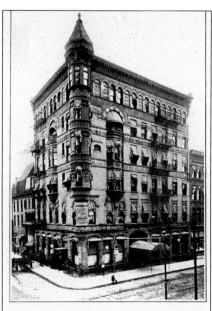

The six-story Clarendon Hotel, on the northwest corner of Washington and Johnson Streets, opposite the Brooklyn Daily Eagle building and the Federal Building, charged $1 per night for its rooms in 1905. Cadman Plaza now occupies the site.

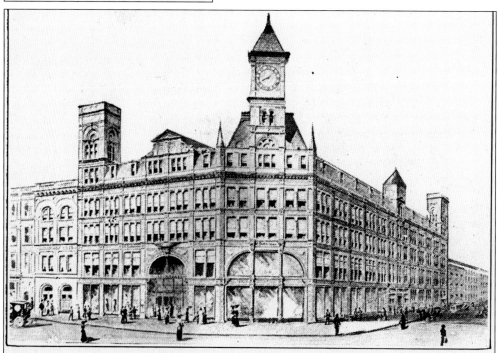

H. Batterman's Department Store, Broadway, Graham and Flushing Aves.

Batterman's stood at the intersection of Broadway and Graham and Flushing Avenues in Williamsburg, and was a major department store of Brooklyn's Eastern District. The store was founded in 1867 at Broadway and Ewen Street (now Manhattan Avenue). It moved in 1881 to the location depicted in this drawing.

The Broadway Bank building, which stood on Graham Avenue near its intersection with Broadway and Flushing Avenue, was next-door to H. Batterman's Department Store. The bank's president was none other than Henry Batterman.

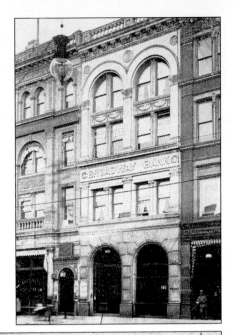

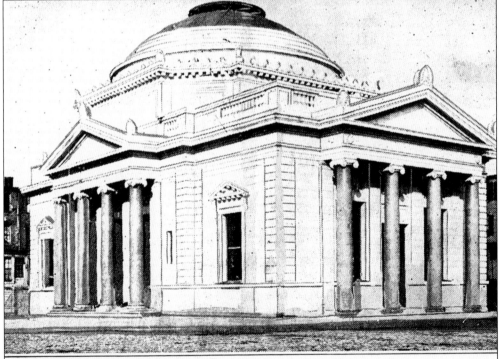

BROOKLYN EAGLE POST CARD, SERIES 15, No. 85.
WILLIAMSBURGH TRUST COMPANY BUILDING, WILLIAMSBURG BRIDGE PLAZA.

Architects Helmle and Huberty used white terra-cotta facing on the Williamsburg Trust Company's building, located on the north side of South Fifth Street at the Williamsburg Bridge Plaza. The building was brand new when this photograph was taken. It is now the Holy Trinity Cathedral of the Ukrainian Orthodox Church.

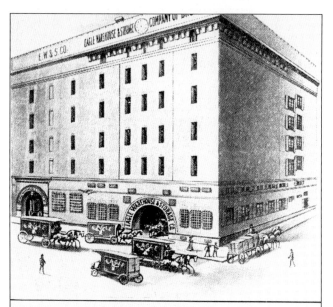

The enormous Eagle Warehouse & Storage Company of Brooklyn building still stands on the south side of Fulton Street, just steps up the hill from the old Fulton Ferry terminal. In 1905 it offered storage for furniture, "electric carpet cleaning," and safe-deposit and silver vaults. Its secretary and treasurer was Herbert F. Gunnison, an early resident of Prospect Park South in Flatbush; he was also business manager (and later president) of the *Eagle* and brother of Dr. Walter B. Gunnison, principal of Erasmus Hall High School in Flatbush. The building has been converted to residential use.

Brooklyn Eagle Post Card, Series 81, No. 482.
Eagle Warehouse and Storage Co., of Brooklyn, 28 to 44 Fulton Street.

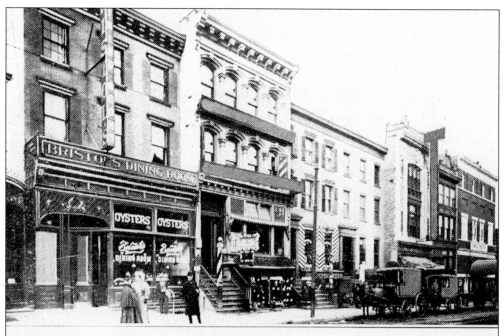

Brooklyn Eagle Post Card, Series 64, No. 383.
View of Willoughby Street, off Fulton.

This view of Willoughby Street off Fulton Street, near the major department stores in what remains Brooklyn's downtown shopping district, shows Bristol's Dining Room, which was an oyster house; a barber shop; and other stores both upstairs and downstairs at street level.

The classical People's Trust Company building, with its tall Corinthian columns and sculpture-filled pediment, dates from 1903. It still stands on the north side of Montague Street between Clinton Street and Court Street in Brooklyn Heights. It is now a Citibank branch.

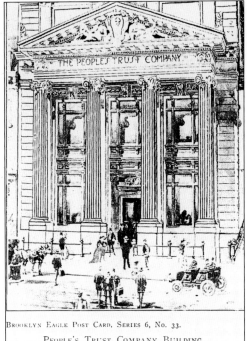

People's Trust Company Building, Montague Street, near Clinton.

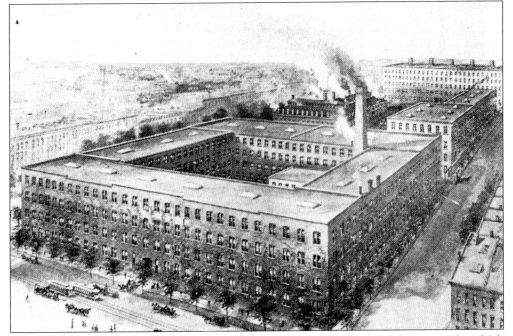

The Ansonia Clock Company, whose factory occupied most of a city block between 7th and 8th Avenues and 12th and 13th Streets in southern Park Slope, was founded in Ansonia, Connecticut, and moved to Brooklyn in 1879. It was said to be the largest clock factory in the world. In 1905, it had more than 1,500 employees. The complex has been converted to residential use.

The elaborate, mansard-roofed Kings County Savings Institution building, on the northeast corner of Broadway and Bedford Avenue in Williamsburg, dates from 1868. It is now home to the Williamsburg Art and Historical Center.

BROOKLYN EAGLE POST CARD, SERIES 69, No. 412.
KINGS CO. SAVINGS INST., B'WAY AND BEDFORD AV

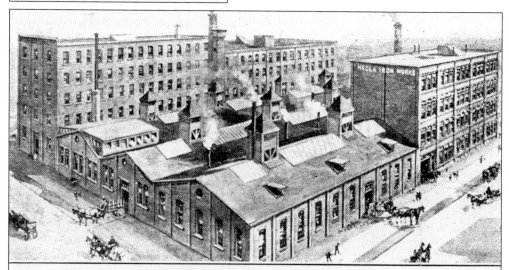

BROOKLYN EAGLE POST CARD, SERIES 66, No. 391.
HECLA IRON WORKS, NORTH ELEVENTH AND BERRY STREETS.

The Hecla Iron Works was founded by Niels Poulson, a Dane, and Charles Michael Eger, a Norwegian, both skilled masons who had developed an interest in architectural iron construction. The name Hecla was reportedly taken from Mount Hekla, a volcano in Iceland. The iron works at one time employed more than 1,000 people. Its 1905 advertising pointed out that it had made 133 kiosks for the rapid-transit subway system. It also manufactured much of the architectural metalwork used in the construction of Manhattan landmarks, such as Grand Central Station.

36

The white marble South Brooklyn Savings Bank building, at the southeast corner of Atlantic Avenue and Clinton Street, dates from 1871 and was designed by Ebenezer L. Roberts. It is still standing and has been converted to residential use.

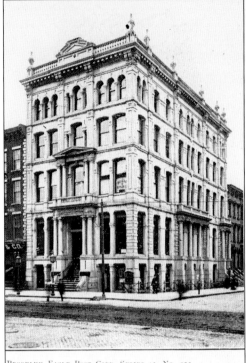

SOUTH BROOKLYN SAVINGS BANK, ATLANTIC AVENUE CORNER CLINTON STREET

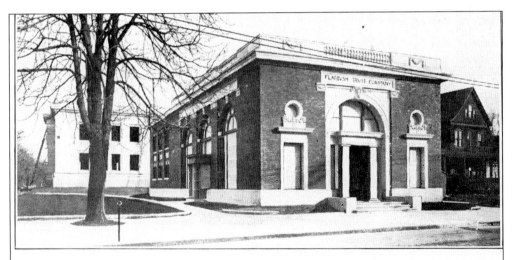

FLATBUSH TRUST COMPANY BUILDING ON FLATBUSH AVENUE.

The Flatbush Trust Company building stood on the east side of Flatbush Avenue just south of Linden Boulevard. The Trust Company was founded in 1899, at the time that residential development in Flatbush was beginning. In 1905, it was still a small local bank. When this photograph was taken, the Flatbush Branch of the Brooklyn Public Library was under construction at the left.

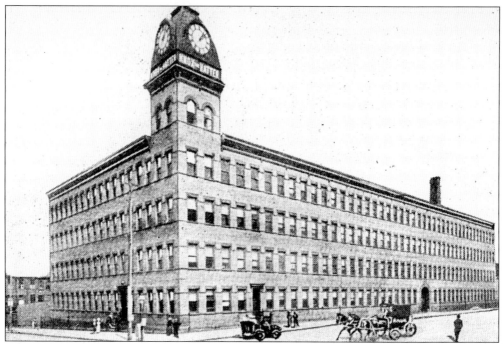

The Knox Hat Factory, on the northeast corner of St. Marks and Grand Avenues, was built *c.* 1885. It made both men's and women's hats, which were sold at hat stores that Knox operated. The business was founded in 1840 and flourished in a time when a hat was a basic part of every adult's everyday dress.

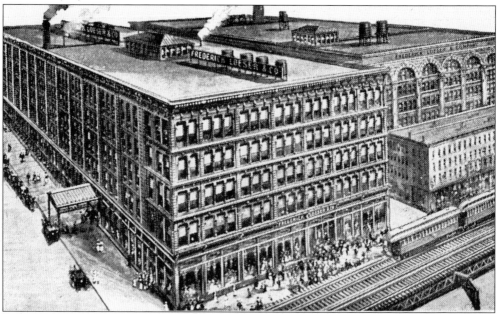

Frederick Loeser & Company's department store on Fulton Street extended from Bond Street to Elm Place in the downtown shopping district. The architect was Francis H. Kimball, who also designed the Montauk Club in Park Slope. The store was previously located at Fulton and Tillary Streets. It moved to the location shown here in 1887.

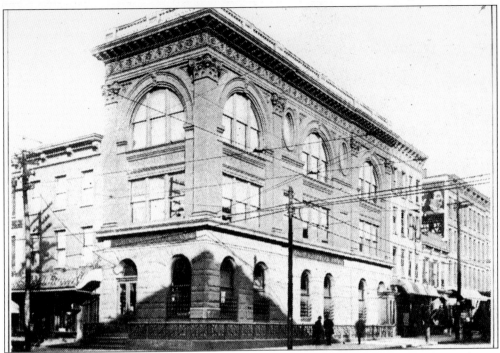

In 1905, when there were many small, independent local banks, this office of the Corn Exchange Bank, on the northeast corner of Franklin Street and Greenpoint Avenue in Greenpoint, was unusual in that it was one of 15 branches of this large banking concern. The building is still standing today.

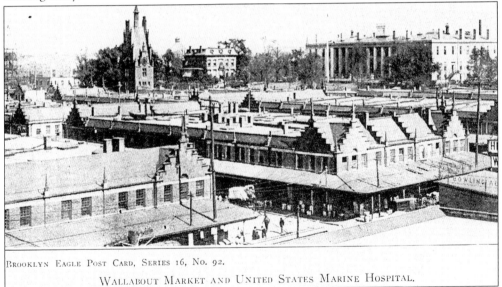

BROOKLYN EAGLE POST CARD, SERIES 16, No. 92.

WALLABOUT MARKET AND UNITED STATES MARINE HOSPITAL.

The Wallabout Market was established by the city of Brooklyn in 1884 as a center to which farmers could bring wagons loaded with produce for sale. It occupied a large area at Clinton and Flushing Avenues, adjoining the Brooklyn Navy Yard, and included piers where railroad cars could be brought in on floats and ships could be loaded for foreign trade. It was demolished at the beginning of World War II in connection with the expansion of the navy yard.

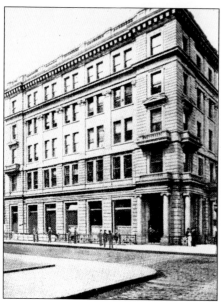

The former Nassau Trust Company building, on the southwest corner of Broadway and Bedford Avenue in Williamsburg, is another stately office building that incorporates classical motifs. It dates from 1888 and was designed by Frank J. Helmle. It is still in use today.

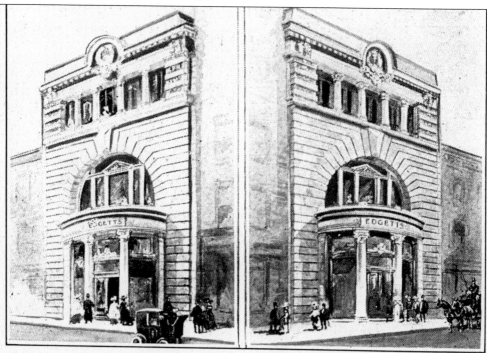

BROOKLYN EAGLE POST CARD, SERIES 74, No. 443.
EDGETT'S RESTAURANT, FULTON ST. AND FLATBUSH AVE.

Although some of the higher-numbered *Eagle* postcards deviated from the norm of showing borough buildings, monuments, landmarks, and street scenes by including pictures of actors and actresses about to appear at Brooklyn theaters, this is the only card depicting a particular dining establishment. In 1904, James W. Edgett opened this fancy restaurant at the southeast corner of Flatbush Avenue and Fulton Street. Edgett's was intended to be the "Delmonico's of Brooklyn." It is now long gone, with no trace of it remaining at the site.

Three
EDUCATION

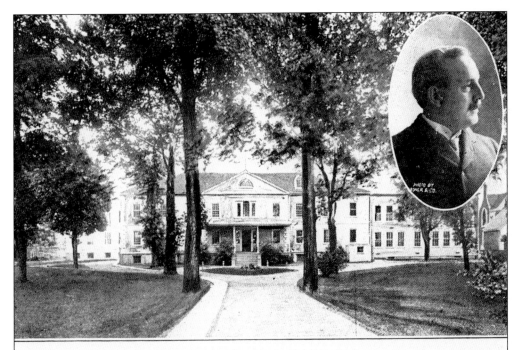

THE OLD ERASMUS HALL AND DR. WALTER B. GUNNISON, PRINCIPAL.

When Erasmus Hall was founded as a private academy in 1787 in what was then the sleepy village of Flatbush, among the subscribing contributors were Alexander Hamilton, John Jay, and Aaron Burr, as well as local citizens from the Dutch families who had settled in the area more than a century earlier. Some of its first students came from as far away as France, Portugal, and the West Indies. Erasmus became part of the Brooklyn public school system in 1896, and Dr. Walter B. Gunnison, a former lawyer and professor at St. Lawrence University, became its principal.

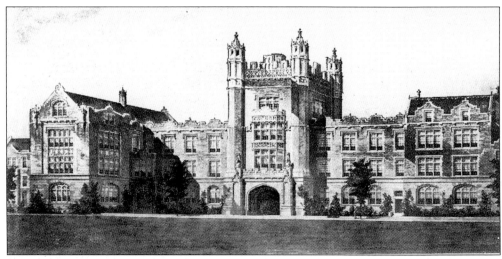

Part of the agreement when the trustees of Erasmus donated the school to the city of Brooklyn was that a new building would be erected "of the same character and grade as other high school buildings" in the city at the time. The cornerstone for the new Erasmus, which surrounds the 1787 frame structure on the east side of Flatbush Avenue just south of Church Avenue, was laid on January 17, 1905. When this postcard was issued, the building was still only partially completed. Erasmus had a national reputation for academic excellence well into the second half of the 20th century.

Girls' High School, on the east side of Nostrand Avenue between Halsey and Macon Streets in Bedford-Stuyvesant, dates from 1885. In 1905, it was the largest high school in Brooklyn, with an enrollment of 2,194. It is still standing and is now used by the board of education as an adult training center.

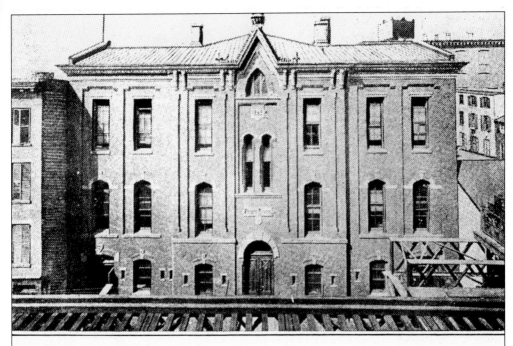

Public School No. 7, York, near Bridge Street.

In his 1943 *New Yorker* piece "A Brooklyn Childhood," Joseph Mulvaney wrote of his sister's tribulations as a young teacher five decades earlier at a tough public school on York Street, where the teachers walked nervously in groups and one of the pupils was a young troublemaker named Alfie Capone. He must have been referring to Public School (P.S.) No. 7, which stood on the north side of York Street between Bridge and Jay Streets, two and a half blocks west of the navy yard and, at that time, in the shadow of the elevated tracks.

Public School No. 119, which still stands on the north side of Avenue K between East 38th and East 39th Streets in the Flatlands section, was still under construction when this photograph was taken in 1904. It is typical of many brick and limestone Brooklyn public school buildings erected in the early years of the 20th century, which appear enormous compared to schools like P.S. 7, built 20 or more years earlier.

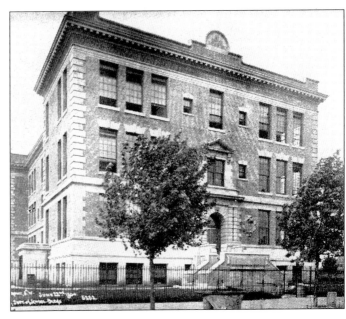

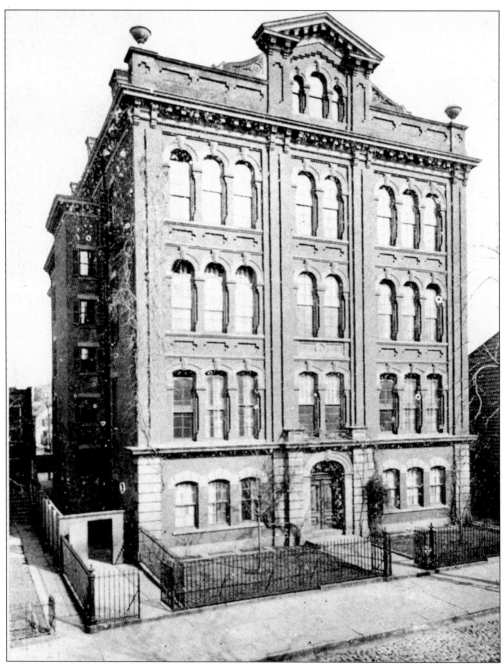

Interestingly, most of the pictures of public schools that appeared on *Brooklyn Daily Eagle* postcards, including this one of P.S. 12, were taken from an 1892 book, *Souvenir of our Public Schools, Brooklyn, New York,* and were, therefore, already 13 years old. This tall, narrow, purplish-brick school faced on the east side of Adelphi Street between Park and Myrtle Avenues, two blocks south of the navy yard, and ran through to Clermont Avenue. In 1905, the school had an enrollment of 1,352 students divided among 31 classes, and the longtime principal was James Cruikshank, who lived at 206 South Oxford Street, within walking distance but in a more fashionable district.

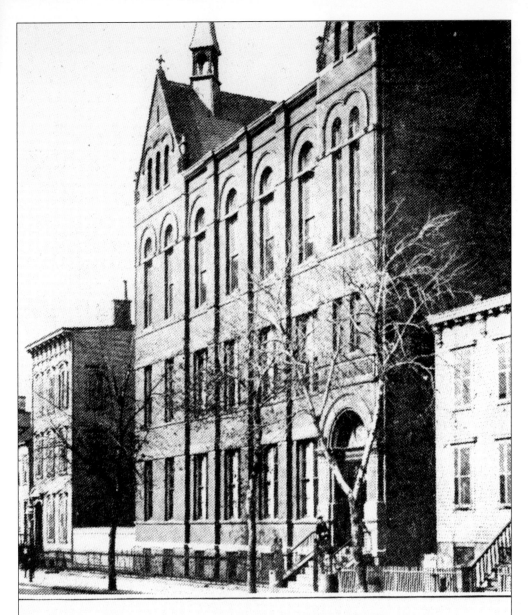

BROOKLYN EAGLE POST CARD, SERIES 58, NO. 346.
ST. BENEDICT'S PAROCHIAL SCHOOL,
HERKIMER STREET, NEAR RALPH AVENUE.

This red brick grammar school on the north side of Herkimer Street between Ralph and Howard Avenues was associated with St. Benedict's Roman Catholic Church, located behind it on Fulton Street. (The church is now Mt. Sinai Cathedral Church of God in Christ, and the school is the Bishop Clarence L. Sexton Head Start Center.) St. Benedict's parish was founded in 1859, and the school dates from 1894. In 1905, it had an enrollment of 275, which was very small in comparison with the local public schools. This photograph must have been taken on a very cold day because the shutters on the little frame houses on both sides of the school are all tightly shut.

45

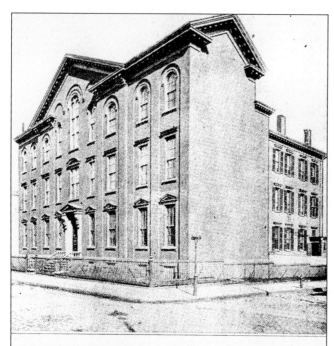

BROOKLYN EAGLE POSTAL CARD, SERIES 49, No. 293.
PUBLIC SCHOOL No. 32, HOYT ST., COR. PRESIDENT ST.

Public School No. 32, on the northeast corner of Hoyt and President Streets, was typical of a number of red brick Brooklyn public schools built in the 1860s. It was replaced by a newer P.S. 32 named for Samuel Mills Sprole, who was principal of the school in 1905.

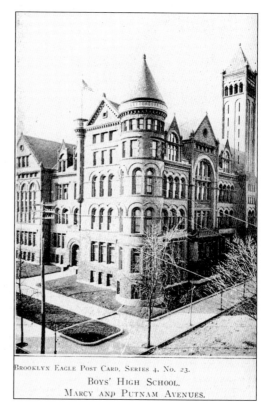

BROOKLYN EAGLE POST CARD, SERIES 4, No. 23.
BOYS' HIGH SCHOOL.
MARCY AND PUTNAM AVENUES.

The ornate and architecturally interesting Boys' High School, on the west side of Marcy Avenue between Putnam Avenue and Madison Street in Bedford-Stuyvesant, dates from 1891 and is another example of Brooklyn's many fine Romanesque Revival buildings of about that time. Like a number of other Brooklyn public schools built in the 1880s and 1890s, it was designed by Irish-born James W. Naughton, who was for many years superintendent of buildings for the city of Brooklyn's board of education.

The Polytechnic Institute of Brooklyn, founded in 1854, was located behind borough hall and faced on Livingston Street east of Court Street. By 1905, the institute specialized in engineering education.

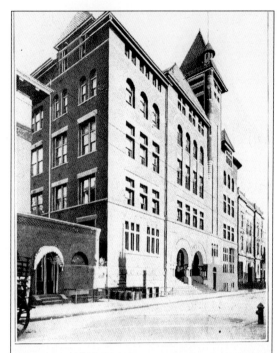

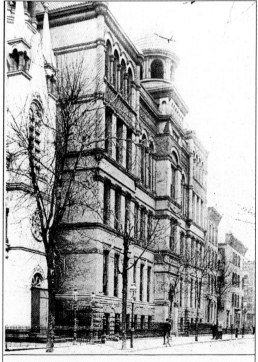

Public School No. 3 was another massive Romanesque Revival building, like nearby Boys' High School, dating from the tenure of James W. Naughton as architect of Brooklyn public schools. It was built in 1891 and stood on the north side of Hancock Street between Franklin and Bedford Avenues, in what was, in 1905, the finest part of the old Bedford neighborhood. It was the successor to a series of schoolhouses in the vicinity dating back to 1663. The Central Congregational Church was located immediately to its left and can be seen in this photograph. The site of both buildings is now occupied by a more modern P.S. 3 and its playground.

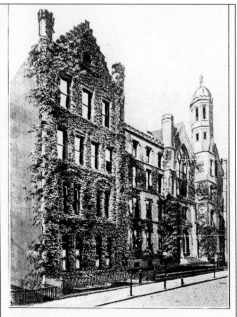

By the turn of the 20th century, a large number of women were attending college, and Packer Collegiate Institute, founded as the Brooklyn Female Academy, was regularly sending its graduates to all of the major women's colleges of the day. Packer was also a center of Brooklyn cultural life. On May 10, 1905, for example, author Henry James gave a well-publicized lecture there on Balzac. Packer is still in operation today.

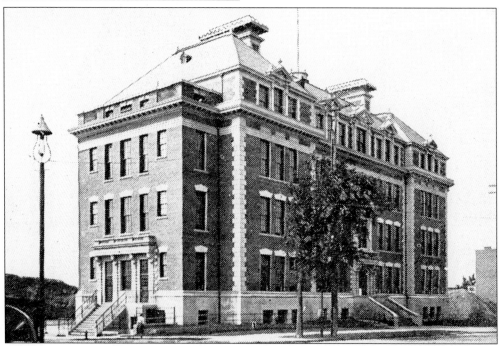

Public School No. 136, on the west side of 4th Avenue between 40th and 41st Streets, was opened on November 11, 1902. It had a regular enrollment of 1,317 students divided among 30 classes and also was home to an evening public elementary school for men and boys. Charles O. Dewey was principal of both the regular and evening divisions, which no doubt made for a very long day. The school is still in use today and is named Charles O. Dewey Junior High School.

The Romanesque Revival-style Public School No. 35 stood on the northwest corner of Lewis Avenue and Decatur Street in Bedford-Stuyvesant. In 1905, female public school teachers were initially paid $600 per year and could hope, ultimately, to earn more than twice that, with $60 per year in additional pay if they had to teach boys or mixed classes. Male teachers received about one and a half times as much as females at every level of experience.

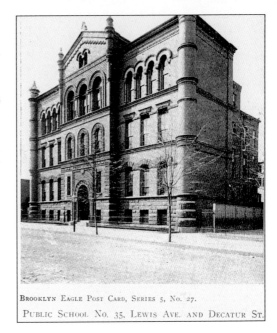

BROOKLYN EAGLE POST CARD, SERIES 5, No. 27.

PUBLIC SCHOOL No. 35, LEWIS AVE. AND DECATUR ST.

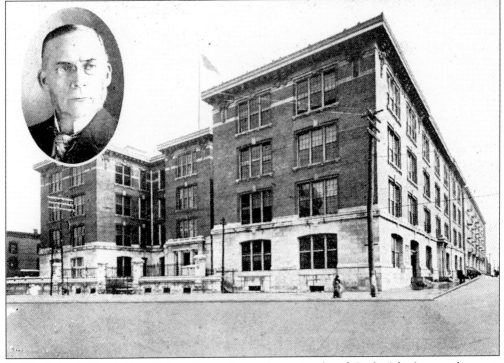

Public School No. 147, which still stands on the east side of Bushwick Avenue between McKibbin and Seigel Streets, was brand new and was the highest-numbered public school in use when this card was published. It was about twice the size of the typical public school building of its day and had an enrollment of more than 4,000 at a time when only 9 of the 147 numbered schools in Brooklyn had enrollments of more than 2,500. Dr. Charles D. Raine was the boys' principal; Mary L. Bayer was the principal of the girls.

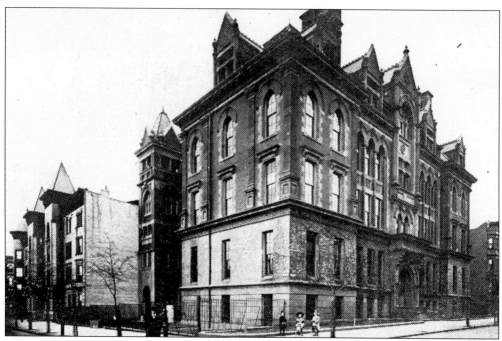

Public School No. 9, on the northeast corner of Vanderbilt Avenue and Sterling Place in the Prospect Heights section, was built in 1895. It is quite different in style from its predecessor, the "old" red brick P.S. 9 on the northwest corner at the same intersection, which dates from 1867 and was renumbered as P.S. 111 after the "new" building was built. Both buildings are still standing today.

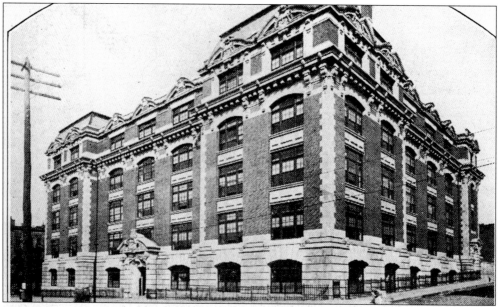

The massive red brick and limestone Manual Training High School on the east side of Seventh Avenue between Fourth and Fifth Streets in Park Slope was brand new when this photograph was taken and had an enrollment of 1,904, with 79 teachers. It is still in use, and for many years has been known as John Jay High School.

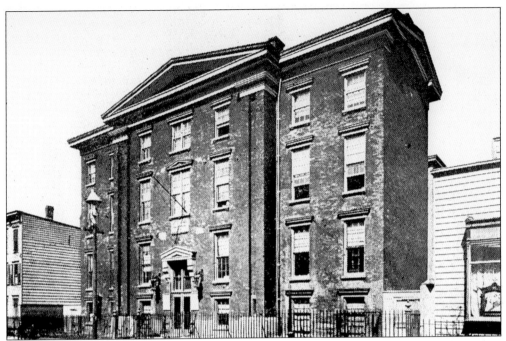

Public School No. 18, built in 1848, was District School No. 3 in the city of Williamsburgh until the consolidation of Williamsburgh with Brooklyn in 1855. In 1905, Edward Bush had been principal for 49 years and would continue until his retirement in 1912 at the age of 82. The school stood on the north side of Maujer Street between Leonard Street and Manhattan Avenue (formerly Ewen Street).

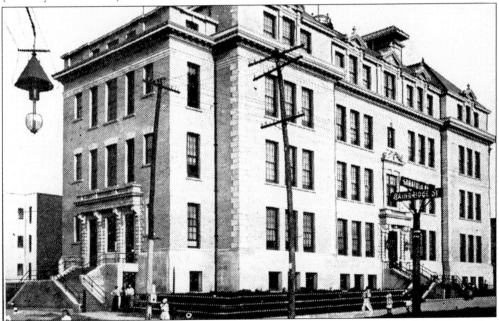

Public School No. 137, which still stands on the east side of Saratoga Avenue between Bainbridge and Chauncey Streets, was another nearly new school when the *Eagle* postcards were issued. Note the old-fashioned street signpost in the foreground and the street lamp at the left.

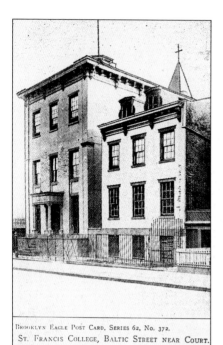

St. Francis College traces its origins to the establishment of St. Francis Academy on Baltic Street by two Irish Franciscan brothers in 1859. The school grew rapidly, both in size and in the breadth and levels of its course offerings, and in 1884, its college program was authorized by the New York legislature to grant degrees. The buildings in this photograph were located on the south side of Baltic Street between Court and Smith Streets.

BROOKLYN EAGLE POST CARD, SERIES 62, NO. 372.
ST. FRANCIS COLLEGE, BALTIC STREET NEAR COURT.

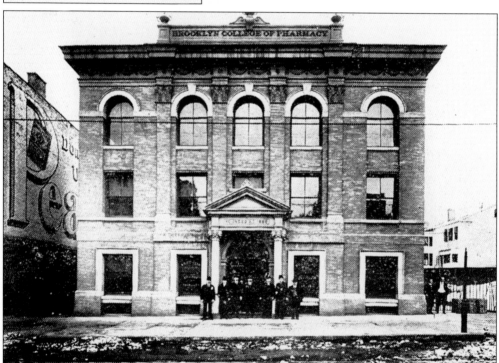

When this photograph was taken, the Brooklyn College of Pharmacy was located on the east side of Nostrand Avenue between Lafayette Avenue and Clifton Place in the Bedford-Stuyvesant section. This newly constructed building blocked the Pear's Soap advertisement painted on the building at the left. The former college building is now used by the Morning Dew Industrious Baptist Church.

Public School No. 37, which stood on the north side of South Fourth Street between Wythe Avenue and Berry Street in Williamsburg, was an example of still another type of Brooklyn public school building. It dated from the 1870s, when Samuel B. Leonard was superintendent of buildings for the city of Brooklyn's board of education. George L. A. Martin was principal from the time the school opened until his death in 1905.

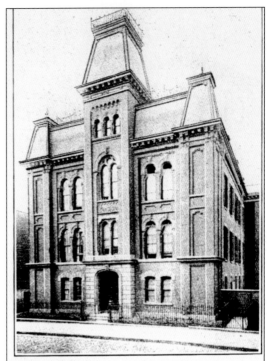

BROOKLYN EAGLE POST CARD, SERIES 47. No. 282.
PUBLIC SCHOOL No. 37, S. FOURTH STREET NEAR BERRY.

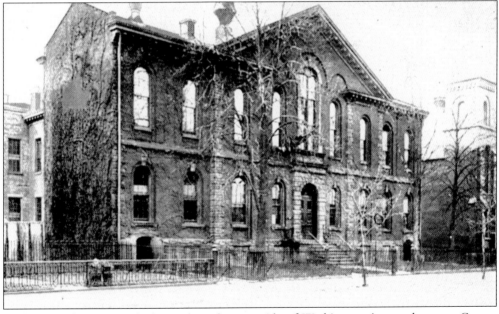

Public School No. 11, which stood on the west side of Washington Avenue between Greene and Gates Avenues until 1960, was built in 1861 and was used as a hospital during the Civil War. It boasted a number of illustrious graduates, including Clifton Fadiman, George S. Kaufman, Edward Everett Horton, and Quentin Reynolds. A playground for a newer P.S. 11, built in 1958, now occupies the site.

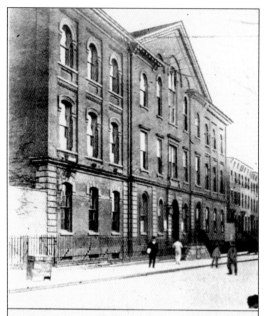

Public School No. 13, which stood on the south side of Degraw Street at its intersection with Cheever Place, was built in 1860. When it closed on June 30, 1961, it was the oldest building still in use as a public school in the entire city of New York. In 1905, the surrounding neighborhood was already largely Italian; at that time, no fewer than 30 Italian societies were located nearby along Union Street.

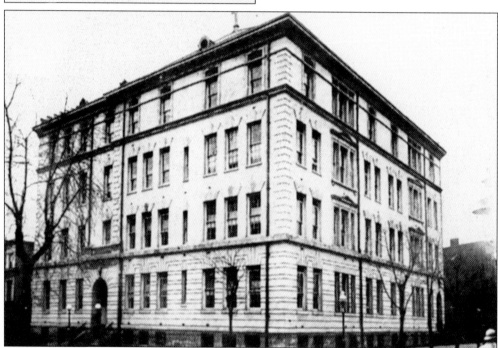

In 1865, Brooklyn's Roman Catholic Bishop, John Loughlin, invited the Vincentian Fathers to found a college in Brooklyn and assigned them a new parish in the vicinity of Lewis and Willoughby Avenues. By 1870, they had opened both a high school and a college at that intersection, and their complex subsequently included the enormous Church of St. John the Baptist (to the east on the same block) and this parochial school on the southwest corner, which dates from 1903 and has been converted to residential use.

Four

RELIGION

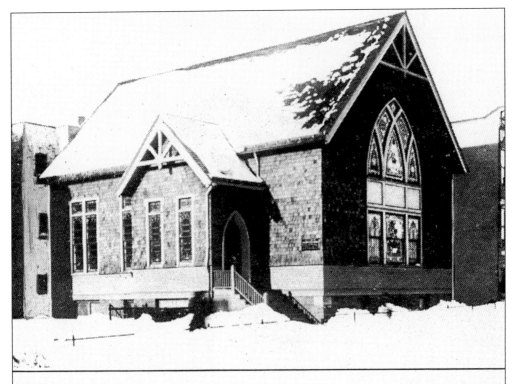

Irving Square Presbyterian Church, Hamburg Ave. and Weirfield St.

The Irving Square Presbyterian Church was located on the northeast corner of Hamburg Avenue and Weirfield Street in the Bushwick section, across from the full-square-block park known as Irving Square. The church was built in 1904 and had a membership of 170. The name of Hamburg Avenue was later changed to Wilson Avenue (after Pres. Woodrow Wilson) because of anti-German sentiment at the time of World War I. The building is now used by a Spanish-language Presbyterian congregation.

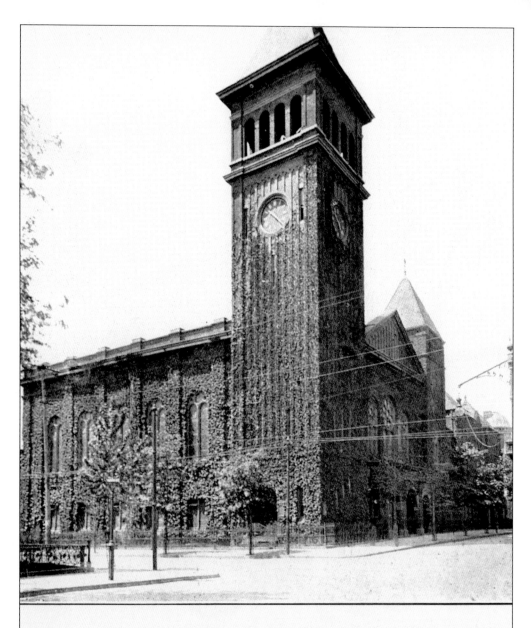

TOMPKINS AVENUE CONGREGATIONAL CHURCH, TOMPKINS AVENUE, CORNER McDONOUGH STREET.

In 1905, when Brooklyn was known as "the borough of churches," the Tompkins Avenue Congregational Church was the premier church of its denomination in the borough in terms of both its membership (2,670) and the value of its property ($260,000). It was founded in 1875 and located in what is now called the Bedford-Stuyvesant section, on the southwest corner of Tompkins Avenue and McDonough Street. The congregation merged with Flatbush Congregational Church at Dorchester Road and East 18th Street in 1942. The Tompkins Avenue building is now occupied by the First African Methodist Episcopal Zion Church.

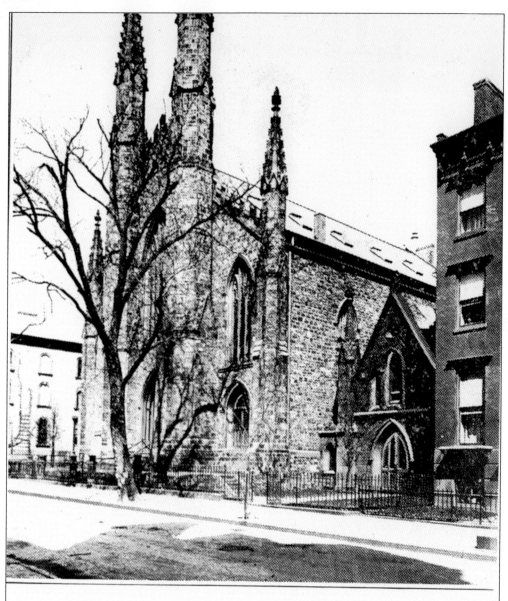

BROOKLYN EAGLE POST CARD, SERIES 45, No. 265.
CHURCH OF OUR SAVIOUR, UNITARIAN, MONROE PLACE
AND PIERREPONT STREET.

The brownstone Gothic-style Unitarian Church of the Saviour, on the northeast corner of Pierrepont Street and Monroe Place, was consecrated on April 24, 1844, and designed by well-known architect Minard Lafever. Lafever, remembered for his architectural copybooks, was himself a Unitarian. He lived on South Seventh Street in Williamsburgh. He also designed two other Brooklyn Heights landmarks, Holy Trinity Church and Packer Collegiate Institute. The Church of the Saviour is adorned by Tiffany windows that were added in the 1890s. It is still in use today and is now called First Unitarian Church.

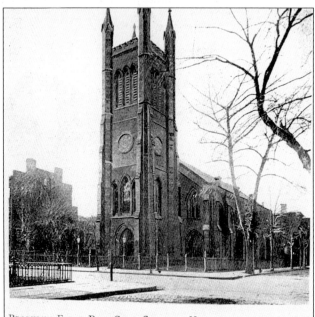

CHRIST PROTESTANT EPISCOPAL CHURCH,
COR. CLINTON AND HARRISON STREETS.

The brownstone Gothic-style Christ Church, an Episcopal church on the southeast corner of Clinton and Kane (formerly Harrison) Streets, dates from 1842. It was designed by Richard Upjohn, the English-born architect who also designed Trinity Church at Wall Street and Broadway in Manhattan and, with his son, Richard M. Upjohn, the elaborate entrance gate to Green-Wood Cemetery. Upjohn lived a block away at 296 Clinton Street and was a parishioner at Christ Church; for designing the church, he was given a lifetime pew.

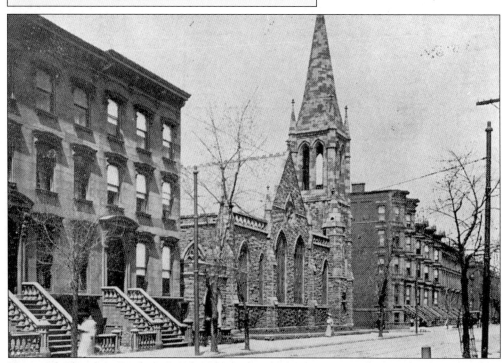

Memorial Church, a Presbyterian church on the southwest corner of Seventh Avenue and St. John's Place in Park Slope, is another of Brooklyn's many 19th-century brownstone Gothic churches. Its cornerstone bears a date of 1882, and it has stained-glass windows by Tiffany. The building is now used by a Spanish-language Presbyterian congregation.

The Roman Catholic Church of Our Lady of Lourdes, which stood at Broadway and DeSales Place, was the successor to the Church of St. Francis de Sales, established by the Society of Fathers of Mercy, a French religious order, in 1872. The cornerstone of the church shown here was laid on October 4, 1896, and the church was formally dedicated on December 9, 1906. A school and residence are still on the site, but the church has been razed.

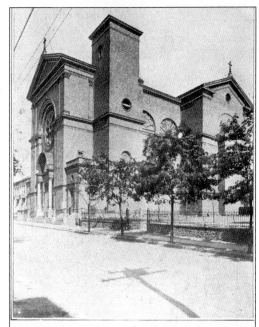

Church of Our Lady of Lourdes,
Broadway and De Sales Place.

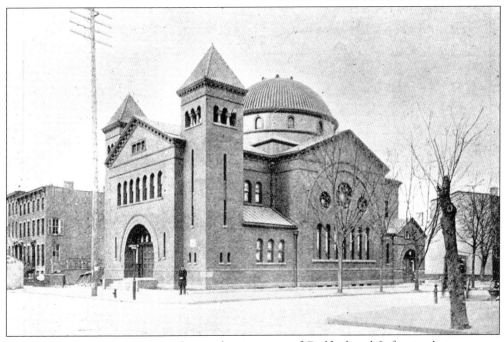

Temple Israel, which stood on the northeast corner of Bedford and Lafayette Avenues, was founded in 1869. In 1905, it was one of the larger Jewish congregations in Brooklyn, with 600 members, and had the most valuable property and the largest annual budget. It subsequently united with Congregation Beth Elohim in Williamsburg to form Union Temple, which is now located in a newer building on the north side of Eastern Parkway, east of Flatbush Avenue.

The Marcy Avenue Baptist Church, on the east side of Marcy Avenue between Madison Street and Putnam Avenue in Bedford-Stuyvesant, was an enormous complex that, at the time it was built, was said to be the largest Baptist edifice under one roof in the country. In 1905, it was also the largest church of its denomination in Brooklyn in terms of membership, with 1,840 members and 2,685 enrolled in its Sunday school. The Concord Baptist Church's 1953 building now occupies the site.

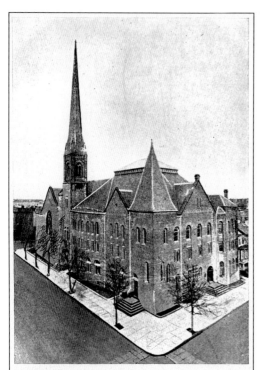

BROOKLYN EAGLE POST CARD, SERIES 7, No. 39.
MARCY AVENUE BAPTIST CHURCH,
CORNER MARCY AND PUTNAM AVENUES.

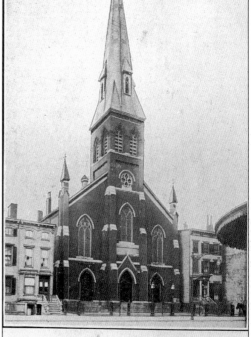

BROOKLYN EAGLE POST CARD, SERIES 74, No. 442.
ST. PETER'S LUTHERAN CHURCH, BEDFORD AVE.

St. Paul's Lutheran Church, on the west side of Bedford Avenue south of DeKalb Avenue, also in the Bedford-Stuyvesant section, was founded in 1867. It was Brooklyn's largest Lutheran congregation in 1905, with a membership of 2,200 and 1,600 enrolled in its Sunday school. Its pastor, Dr. John J. Heischmann, was one of Brooklyn's leading German clergymen. The church is still in use today, although its steeple has been removed.

The Gothic-style St. Ann's Protestant Episcopal Church, on the northeast corner of Livingston and Clinton Streets in Brooklyn Heights, dates from 1869 and is notable for its polychrome brick and stonework. The architect, James Renwick Jr., also designed two important Manhattan churches, Grace Church at Broadway and 10th Street and St. Patrick's Cathedral. St. Ann's was the oldest Episcopal congregation in Brooklyn, dating from 1784. The church is now owned by Packer Collegiate Institute, and St. Ann's parish has merged with Holy Trinity on Montague Street.

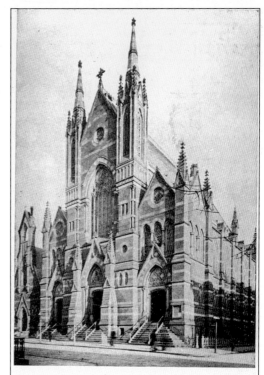

BROOKLYN EAGLE POST CARD, SERIES 17, No. 98.
ST. ANN'S P. E. CHURCH, CLINTON AND LIVINGSTON STS.

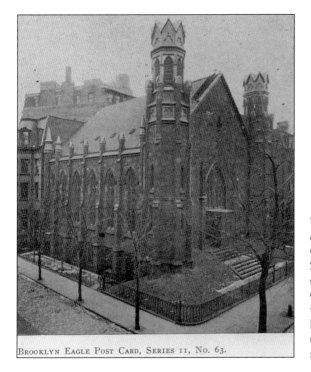

BROOKLYN EAGLE POST CARD, SERIES 11, No. 63.

This unusual-looking building, designed by Minard Lafever, was the Church of the New Jerusalem, a Swedenborgian church on the southeast corner of Monroe Place and Clark Street in Brooklyn Heights. It was founded in 1858, and in 1905, it had a membership of 200. The site of the church is now occupied by a modern apartment complex.

The Roman Catholic Church of St. Charles Borromeo, on the northeast corner of Sidney Place and Aitken Place in the southern part of Brooklyn Heights, dates from 1869. It was designed by Irish-born Patrick C. Keely. He resided at 257 Clermont Avenue in the Fort Greene section of Brooklyn and was an extremely prolific architect who designed hundreds of churches, almost all of them Catholic. This red brick Gothic church is still in use today.

BROOKLYN EAGLE POST CARD, SERIES 60, No. 359.
CHURCH OF ST. CHARLES BARROMEO, SYDNEY PLACE
AND LIVINGSTON STREET.

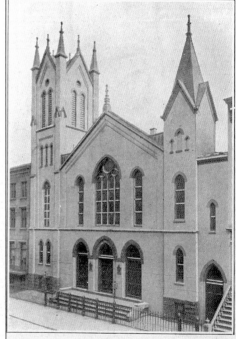

BROOKLYN EAGLE POST CARD, SERIES 12, No. 67.
GERMAN EVANGELICAL LUTHERAN ZION CHURCH,
HENRY ST., WHICH RECENTLY CELEBRATED ITS
FIFTIETH ANNIVERSARY.

The German Evangelical Lutheran Zion Church, on the east side of Henry Street south of Clark Street in Brooklyn Heights, was founded in 1855. Upon the celebration of its 50th anniversary in 1905, it had 1,200 members and 500 enrolled in its Sunday school. The church is still in operation today and is one of the few churches in the New York metropolitan area that still conducts German-language as well as English-language services.

The South Third Street Presbyterian
Church, which stood on the northwest
corner of South Third Street and Driggs
Avenue in the Williamsburg section, was
founded in 1844, and the church's
cornerstone was also laid in that year. In
1905, it had a membership of 507, with
642 enrolled in its Sunday school. Rev.
John D. Wells had served as pastor from
1850 until his death in 1903 and was
succeeded by his son, Newell Woolsey
Wells, DD. A modern Spanish-language
Presbyterian church with a cornerstone
dated 1968 now occupies the site.

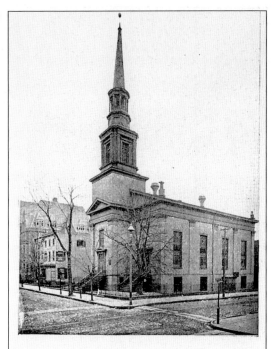

BROOKLYN EAGLE POST CARD, SERIES 8, NO. 45.
SOUTH 3D STREET PRESBYTERIAN CHURCH,
S. 3D ST. AND DRIGGS AVE.

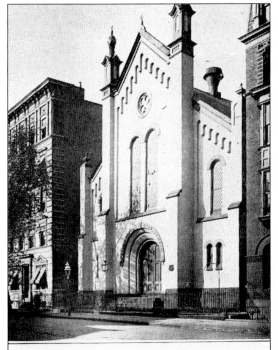

BROOKLYN EAGLE POST CARD, SERIES 20, NO. 118.
SYNAGOGUE BETH ELOHIM, STATE STREET, NEAR HOYT.

Congregation Beth Elohim, which stood
on the north side of State Street between
Smith and Hoyt Streets in the area now
known as Boerum Hill, was founded in
1861. It was the largest Jewish
congregation in Brooklyn in 1905, with
1,000 members. The congregation
subsequently moved to its present
location at Eighth Avenue and Garfield
Place in Park Slope.

63

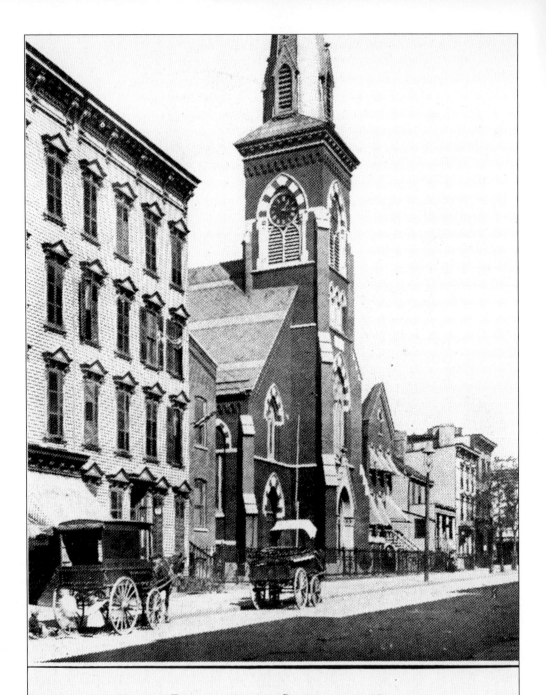

BROOKLYN EAGLE POSTAL CARD, SERIES 53, No. 314.

ST. JOHN'S EVAN. LUTHERAN CHURCH, MAUJER ST.

St. John's Evangelical Lutheran Church (formerly St. Johannes, a German-speaking congregation), on the north side of Maujer Street between Graham Avenue and Humboldt Street in the Williamsburg section, dates from 1883. It is still standing and looks very much the same today.

64

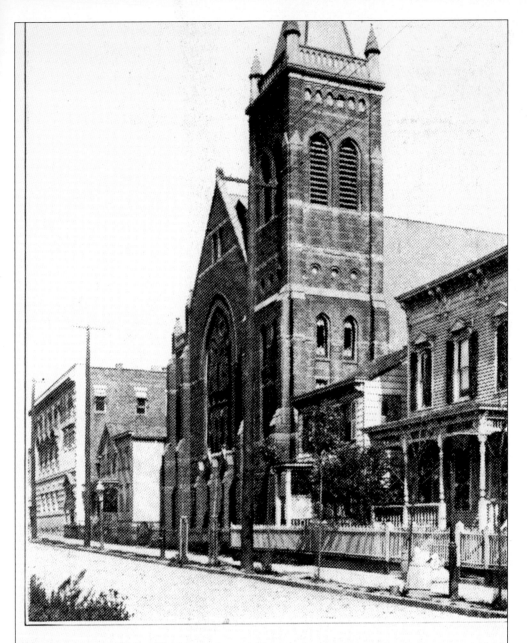

ST. JOHN'S LUTHERAN CHURCH.

Another St. John's Lutheran Church, on the east side of New Jersey Avenue between Liberty and Glenmore Avenues, was dedicated in 1898 and was also home to a German congregation. In 1905, it had a membership of 750. The building is now used by the Grace Baptist Church. The frame house in the foreground is a good example of what houses of its type looked like before the removal or covering of cornices, window pediments and shutters and the destruction of often ornately detailed porches in order to install asphalt, asbestos, aluminum, or vinyl replacement siding.

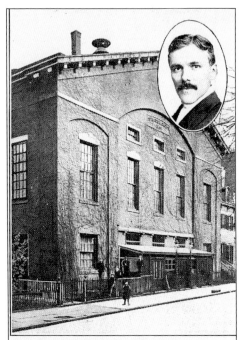

Plymouth Church, on the north side of Orange Street between Hicks and Henry Streets in Brooklyn Heights, was the church of Rev. Henry Ward Beecher, one of the most prominent Brooklynites of his day, from the time it was built in 1849 until his death in 1887. Beecher was a noted abolitionist and fiery preacher whose sister, Harriet Beecher Stowe, wrote *Uncle Tom's Cabin*. Since 1934, when it merged with the former Congregational Church of the Pilgrims on the northeast corner of Remsen and Hicks Streets, it has been known as Plymouth Church of the Pilgrims.

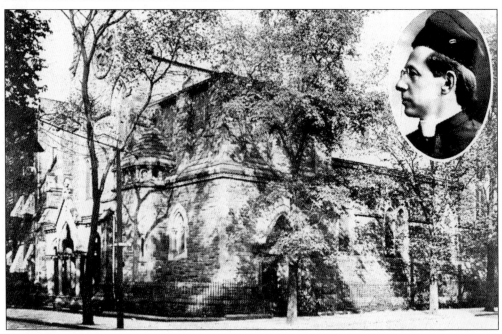

St. Paul's Episcopal Church, on the northeast corner of Clinton and Carroll Streets in the area now known as Carroll Gardens, is a dark gray Gothic stone church with brownstone trim. It was designed by Richard Upjohn & Son. The church was established in 1849; the building dates from 1867-1884 and is still in use today. In 1905, the rector was Rev. Werner E. L. Ward (shown).

In 1905, the Lafayette Avenue Presbyterian Church, on the southeast corner of Lafayette Avenue and South Oxford Street in the Fort Greene section, was the largest Presbyterian congregation in Brooklyn, with a membership of 2,400 and an enrollment of 1,900 in its Sunday school. Its handsome brownstone building is adorned with Tiffany stained-glass windows. For many years it counted among its parishioners the poet Marianne Moore, who lived around the corner at 260 Cumberland Street. Founded in 1857, the church is still thriving today.

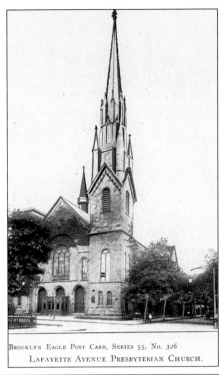

BROOKLYN EAGLE POST CARD, SERIES 55, No. 326
LAFAYETTE AVENUE PRESBYTERIAN CHURCH.

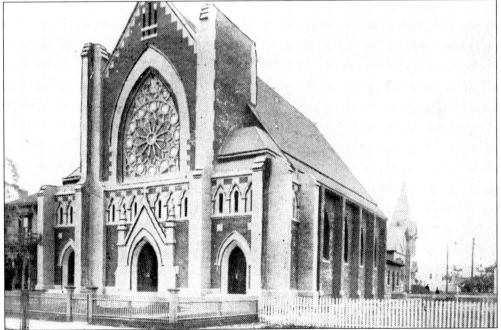

The Roman Catholic Church of the Guardian Angel in Coney Island was established in 1880, and the cornerstone of this church building is dated 1900. The church still stands on the west side of Ocean Parkway, north of Neptune Avenue. In 1905, with only 350 parishioners, it was one of the smallest Catholic parishes in Brooklyn and one of the few that did not operate its own school.

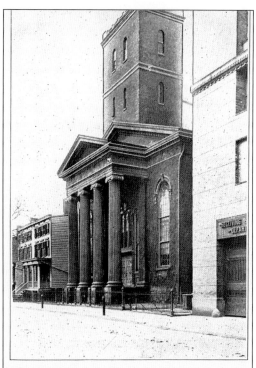

OLD BROOKLYN TABERNACLE.

The Old Brooklyn Tabernacle was an unusual Presbyterian church, built in 1874, which stood on the north side of Schermerhorn Street between Third Avenue and Nevins Street. It was formerly the home of well-known preacher and author T. DeWitt Talmage. By 1905, strangely enough, it had already been used for many years as a public school rather than a church. It served as P.S. 47 until a new building with that number, still under construction in 1905, was built nearby on Pacific Street.

The brownstone Gothic-style Clinton Avenue Congregational Church dated from 1853. It was designed by James Renwick Jr. and stood on the southwest corner of Clinton and Lafayette Avenues. It was torn down and replaced by a new building in 1923. The church has been renamed Cadman Memorial Congregational Church after well-known Brooklyn Congregational clergyman S. Parkes Cadman, for whom Cadman Plaza was also named.

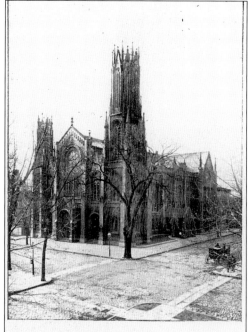

CLINTON AVENUE CONGREGATIONAL CHURCH,
CLINTON AND LAFAYETTE AVENUES.

68

The Romanesque Revival-style Baptist Temple, which still stands on the southwest corner of Schermerhorn Street and Third Avenue, was the oldest Baptist congregation in Brooklyn in 1905 and had the largest Sunday school, with an enrollment of 2,700. Its cornerstone was laid in 1894. The church was founded in 1823 and was formerly located on Pierrepont Street in Brooklyn Heights. The congregation was, therefore, still known as "First in Pierrepont" despite its move to the Schermerhorn Street location.

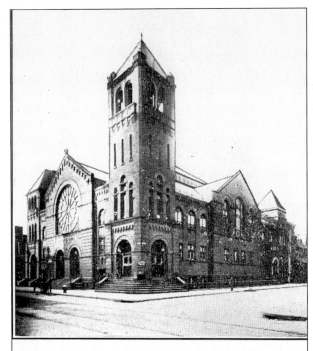

BROOKLYN EAGLE POST CARD, SERIES 72, NO. 430.
BAPTIST TEMPLE, SCHERMERHORN ST. AND THIRD AVE.

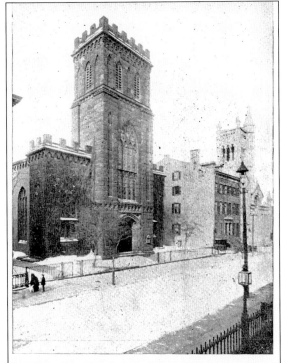

BROOKLYN EAGLE POSTAL CARD, SERIES 49, NO. 292.
FIRST PRESBYTERIAN CHURCH, HENRY ST., NEAR CLARK.

First Presbyterian Church, on the west side of Henry Street south of Clark Street in Brooklyn Heights, is Brooklyn's earliest Presbyterian congregation, founded in 1822. In 1905, it was the borough's third largest, with a membership of 1,420. The building dates from 1846 and is still in use today.

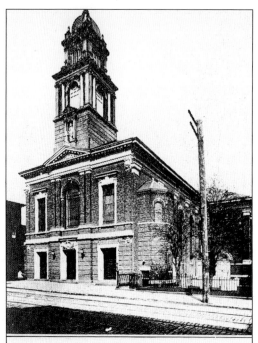

Brooklyn Eagle Post Card, Series 48, No. 288.
St. James Pro Cathedral, Jay and Chapel Streets.

St. James Pro Cathedral (now simply St. James Cathedral) is located on the east side of Jay Street between Cathedral Place and Chapel Street in the downtown area. It is the successor to Brooklyn's first Roman Catholic church, founded in 1822 by the Roman Catholic Society, a group of primarily Irish-born residents of what was then the small village of Brooklyn. The present Georgian building seen in this photograph dates from 1903.

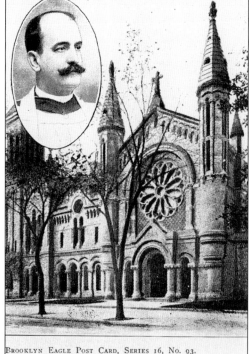

Brooklyn Eagle Post Card, Series 16, No. 93.
St. Luke's P. E. Church, Clinton Avenue; Rev. Henry C. Swentzel, Rector.

The terra-cotta ornamented, Romanesque Revival-style St. Luke's Protestant Episcopal Church, on the west side of Clinton Avenue between Fulton Street and Atlantic Avenue, dates from 1891. It was designed by John W. Welch, a Scottish-born architect who also designed the similar Sands Street Memorial Methodist Episcopal Church building in Brooklyn Heights (shown on the next page). The church was organized in 1842 and is now the Episcopal Church of St. Luke and St. Matthew.

The Sands Street Methodist Episcopal Church, "the mother of Brooklyn Methodist churches," was established in 1794, when Brooklyn was an outpost of fewer than 2,000 people in what is now called the downtown area. When the Brooklyn Bridge was being built more than 80 years later, the church turned down an offer of $125,000 from the bridge company for its 1844 brick building on Sands Street near Fulton Street. Within several years, however, it had moved into its new building on the southwest corner of Henry and Clark Streets, only a short walk from its old location but in more fashionable Brooklyn Heights. An apartment building now occupies the site.

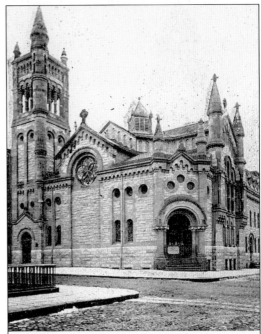

BROOKLYN EAGLE POSTAL CARD, SERIES 51, No. 302.

SANDS STREET MEMORIAL M. E. CHURCH, HENRY STREET, COR. CLARK.

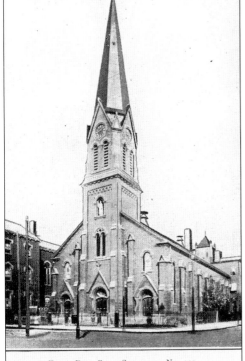

BROOKLYN EAGLE POST CARD, SERIES 57, No. 337.

ST. PETER'S CHURCH, HICKS AND WARREN STREETS.

St. Peter's, on the northeast corner of Hicks and Warren Streets in the area now known as Cobble Hill, is another Roman Catholic church designed by architect Patrick C. Keely. It dates from 1860. At the time of this writing, it is being converted into condominiums.

71

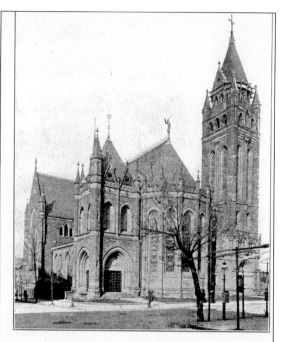

ST. AUGUSTINE'S R. C. CHURCH, SIXTH AVENUE,
COR. STERLING PLACE.

The magnificent brownstone St. Augustine's Roman Catholic Church, which still stands on the northwest corner of Sixth Avenue and Sterling Place in Park Slope, was designed by Parfitt Brothers, an architectural firm of three brothers, Henry, Walter and Albert Parfitt. The brothers lived in Brooklyn and designed a number of other ecclesiastical, commercial, and residential buildings in the borough. The church's cornerstone is dated 1888.

The Grace Methodist Episcopal Church, on the northeast corner of Seventh Avenue and St. John's Place in Park Slope, dates from 1882. It was also designed by Parfitt Brothers. This unusual and attractive sandstone and terra-cotta building with flying buttresses is still in use today.

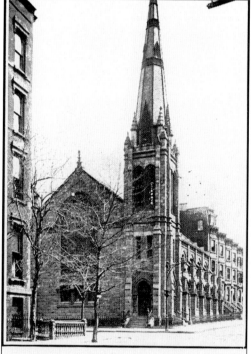

GRACE METHODIST EPISCOPAL CHURCH, SEVENTH
AVENUE, CORNER ST. JOHN'S PLACE.

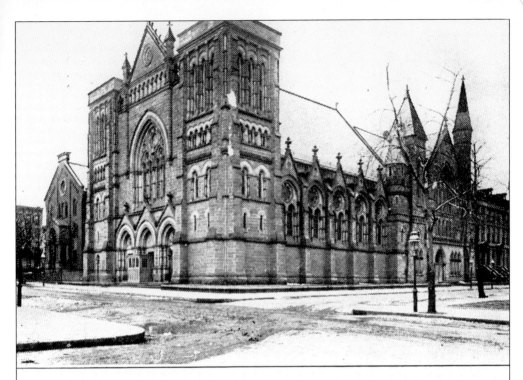

EMANUEL BAPTIST CHURCH, LAFAYETTE AVE. AND ST. JAMES PLACE.

Emmanuel Baptist Church, on the northwest corner of Lafayette Avenue and St. James Place, was designed by Francis H. Kimball in the French Gothic style. It dates from 1887. Its construction was funded by Charles Pratt, who established nearby Pratt Institute in the same year.

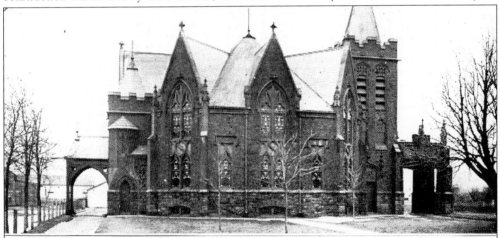

FIRST DUTCH REFORMED CHURCH, GRAVESEND.

The First Dutch Reformed Church of the old English settlement of Gravesend, located at Gravesend Neck Road and East First Street, celebrated its 250th anniversary on March 19, 1905. At the time, it had 275 members and 500 enrolled in its Sunday school. The building is now used by the Trinity Tabernacle of Gravesend.

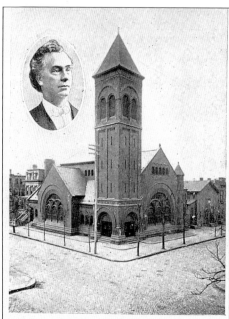

The Throop Avenue Presbyterian Church, which stood on the southwest corner of Throop and Willoughby Avenues in Bedford-Stuyvesant, was founded in 1862. This handsome brick building was dedicated on November 5, 1890. In 1905, it had a membership of 933, with 1,563 enrolled in its Sunday school. The church was destroyed by fire on November 21, 1910. Throop Avenue, like the streets parallel to it, was named for a former New York State governor, in this case Enos T. Throop.

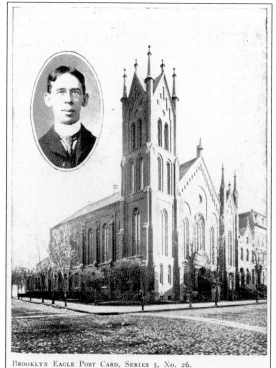

The cornerstone of the red brick Simpson Methodist Episcopal Church, on the southeast corner of Clermont and Willoughby Avenues, was laid in 1869. In 1905, it had a membership of 745. The building is still standing today, and is now used by the French Speaking Baptist Church.

74

St. Joseph's Roman Catholic Church, on the south side of Pacific Street between Vanderbilt and Underhill Avenues, was built in 1859. The clock in its spire was reportedly the first in Brooklyn to strike the hours. The parish was organized in 1852 and, in 1905, had 8,000 parishioners. The building in this photograph has been replaced by a building dating from 1912.

BROOKLYN EAGLE POST CARD, SERIES 46, NO. 275.
ST. JOSEPH'S R. C. CHURCH, VANDERBILT AVENUE
AND PACIFIC STREET.

BROOKLYN EAGLE POSTAL CARD, SERIES 50, NO. 295.
CONGREGATION BETH ISRAEL, TOMPKINS PLACE
AND HARRISON STREET.

The Congregation Beth Israel building, on the southeast corner of Tompkins Place and Kane (formerly Harrison) Street in the area now known as Cobble Hill, was built in 1856. The building was previously occupied by the Trinity German Lutheran Church and, before that, the Middle Dutch Reformed Church. The congregation was established elsewhere in 1856 and, in 1905, had a membership of 500.

75

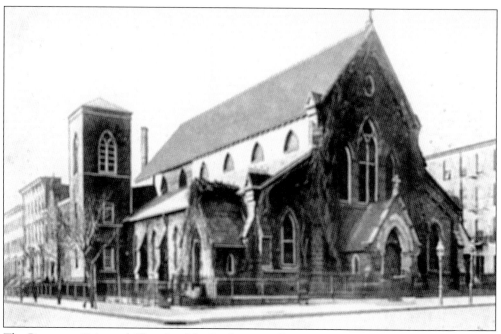

The Protestant Episcopal Church of the Redeemer still stands on the northeast corner of Fourth Avenue and Pacific Street. It was organized in 1853 and, in 1905, had a membership of 450. The building dates from 1870 and is one of the few churches designed by architect Patrick C. Keely that is not Roman Catholic.

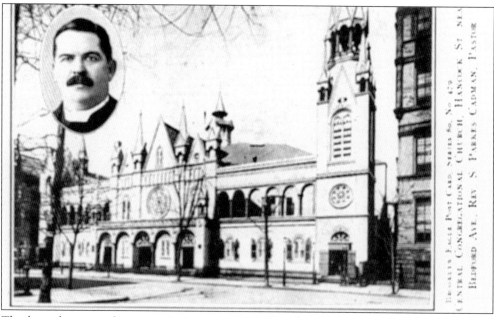

The long, low, wooden Central Congregational Church, which stood on the north side of Hancock Street between Franklin and Bedford Avenues in the old Bedford section, was home to the second-largest congregation of its denomination in Brooklyn in 1905, with a membership of 2,000. This number reflects the great popularity of its pastor, renowned preacher S. Parkes Cadman.

76

Five

CHARITABLE AND CULTURAL INSTITUTIONS

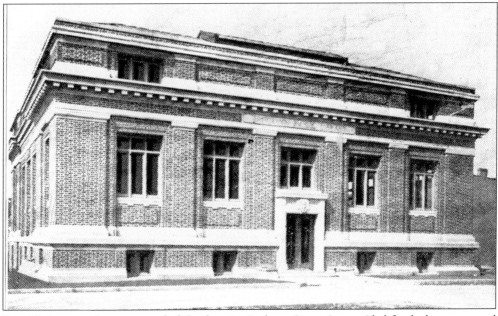

Scottish-born steel magnate and philanthropist Andrew Carnegie provided funds that were used to build 21 branch libraries in the Brooklyn Public Library system. The Carnegie libraries are similar in architectural style and are typically low, wide brick structures with classical facades. This library, on the northwest corner of 4th Avenue and 51st Street, was opened on December 9, 1905, and was called the South Branch because it was at the southern end of the developed part of the borough at the time that it was built. It was demolished and replaced by a more modern building in 1972.

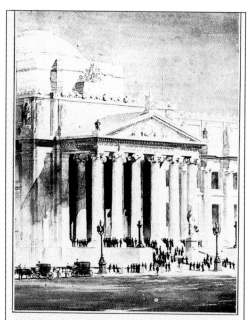

This view of the proposed main entrance on Eastern Parkway to the Brooklyn Museum (now the Brooklyn Museum of Art) is from architects McKim, Mead & White's rendering of their design. It is a detail of the full view that appeared on *Eagle* postcard No. 7, and it shows how the entrance actually looked when it was built. During the 1930s, the entrance lobby was moved downstairs to the ground floor, and the entrance staircase was removed.

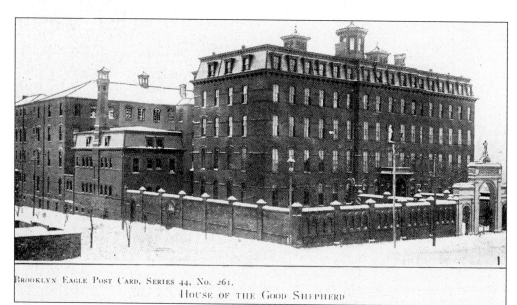

The high-walled, imposing House of the Good Shepherd was a Catholic reformatory for women and girls established in 1868. In 1905, it had 768 inmates. Its building dated from 1872 and stood at the west end of the block bounded by Rockaway Avenue on the east, Hopkinson Avenue on the west, Pacific Street on the north, and Dean Street on the south. A modern apartment complex now occupies the site.

The Young Women's Christian Association (YWCA) building, which stood on the south side of Schermerhorn Street just west of Flatbush Avenue, was opened in 1892 and included classrooms, meeting rooms, a library, and a gymnasium with a running track. In 1905, the YWCA. offered courses in commercial subjects, home economics, and languages at this location. It also had boarding facilities at 368–370 Union Street, where young women could live for $2.50–$4 per week. Part of Public School No. 15 is at the right of the photograph.

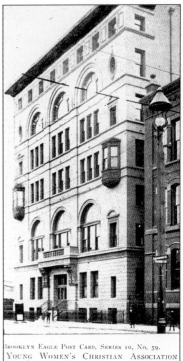

Brooklyn Eagle Post Card, Series 10, No. 59.
Young Women's Christian Association Building, Schermerhorn Street and Flatbush Avenue.

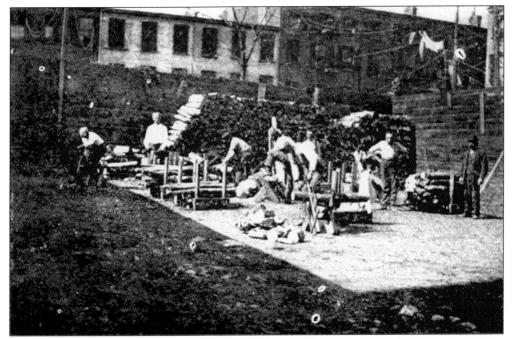

In 1905, the Brooklyn Bureau of Charities operated several "wood yards" in the borough to provide temporary employment to indigent men. This one was located on the south side of Pacific Street east of Hicks Street and employed 372 men over the year. The site is now within the Long Island College Hospital complex.

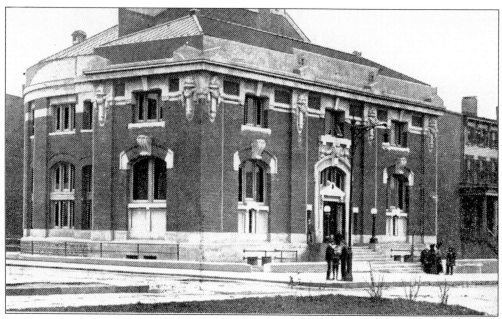

This branch of the Brooklyn Public Library, on the southeast corner of Fourth Avenue and Pacific Street, was opened on October 8, 1904, and was the first of the libraries funded by Andrew Carnegie in Brooklyn. It had a second-floor children's room, with specially designed tables and chairs, that at the time was called the best equipped in the country. The architect was Brooklyn-born Raymond F. Almirall, who studied at the Ecole des Beaux-Arts in Paris and subsequently returned to France, where he was made a chevalier of the Legion of Honor. The library, known as the Pacific Branch, continues to operate today.

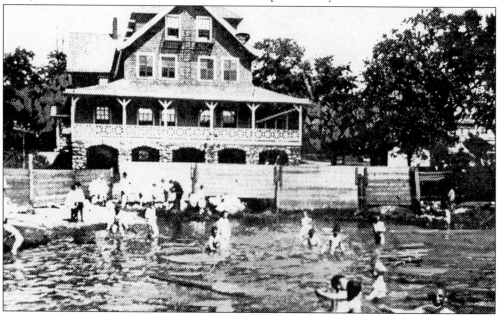

The Seaside Home, in Coney Island, was established in 1876 under the auspices of the Brooklyn Children's Aid Society to provide outings ranging from day trips to two-week stays for mothers and their sick children.

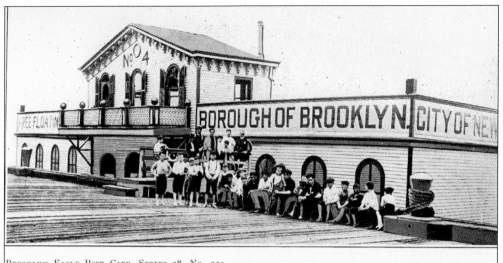

FREE FLOATING BATHS, FOOT OF CONOVER STREET.

In 1905, the free floating baths at the foot of Conover Street in Red Hook were one of five "public river baths" open from June to September along the Brooklyn waterfront. At the time in Red Hook, boys like those in the photograph would ask a stranger "What do you eat, cake or pie?" and the answer would determine his fate. ("Cake" meant you were aligned with the "Creekers" from the east side of Red Hook, and "pie" meant you were a "Pointer" from the west side.)

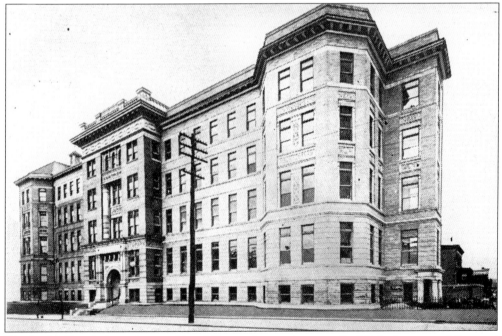

The Jewish Hospital, on the east side of Classon Avenue between St. Marks Avenue and Prospect Place, was newly opened when this photograph was taken. Its president was Abraham Abraham of the Abraham & Straus department store. He lived in a lavish brick mansion at 800 St. Marks Avenue, near New York Avenue.

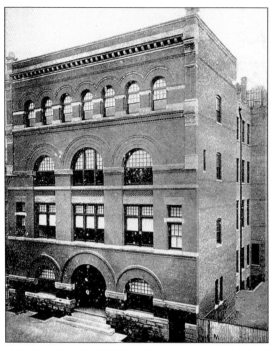

The Brooklyn Bureau of Charities was incorporated in 1887 and operated a variety of programs to accomplish its purposes of promoting the welfare of the poor, suffering, and friendless. It occupied this Romanesque Revival building on the north side of Schermerhorn Street west of Court Street. The building is now used by Community Prep School.

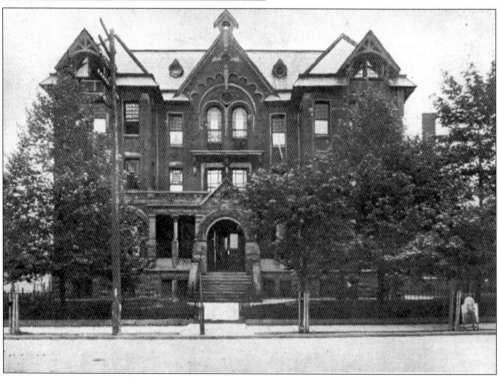

The Brooklyn Home for Aged Men and Aged Couples stood on the east side of Classon Avenue between Prospect Place and Park Place. The home was established in 1878 to care for men and couples over 70 years of age, and in 1905, had 70 residents. A modern healthcare facility now occupies the site.

Established in 1869 as St. Vincent's Home of the City of Brooklyn for the Care and Instruction of Poor and Friendless Boys, this home was known for many years for being a residence for newsboys. It originally occupied adjacent buildings at 10 Vine Street and 7 Poplar Street just east of Columbia Heights in Brooklyn Heights, not far from Brooklyn's newspaper offices. Its new building on the southwest corner of Boerum Place and State Street had just been completed when this postcard was issued; the building was dedicated in June 1906.

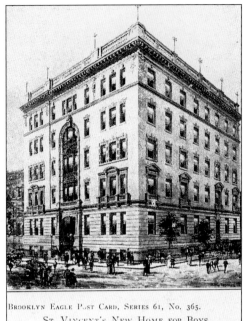

BROOKLYN EAGLE POST CARD, SERIES 61, No. 365.
ST. VINCENT'S NEW HOME FOR BOYS.

BROOKLYN EAGLE POST CARD, SERIES 41, No. 242.
NEW SWEDISH HOSPITAL, STERLING PLACE AND ROGERS AVENUE

The Swedish Hospital was organized in 1896 with the object of building and maintaining a hospital for Swedes. Its building, which stood on the southwest corner of Rogers Avenue and Sterling Place, was newly opened when this photograph was taken.

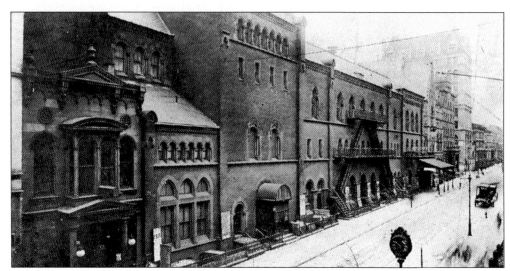

The old Brooklyn Academy of Music opened in 1861 and was located on the south side of Montague Street east of Clinton Street in Brooklyn Heights. All of the notable theater personalities of the day performed there, including Sarah Bernhardt, Edwin Booth, and his infamous brother, John Wilkes Booth. When the building was destroyed by fire on November 30, 1903, planning began immediately for its replacement. On January 30, 1905, the site for the new Academy of Music on the south side of Lafayette Avenue between Ashland Place and St. Felix Street was formally approved. The building was completed in 1908 and is still in use today.

The new morgue, which opened on January 24, 1905, was on the south side of Willoughby Street behind the Raymond Street Jail, just outside Fort Greene Park. It was operated by the Department of Public Charities.

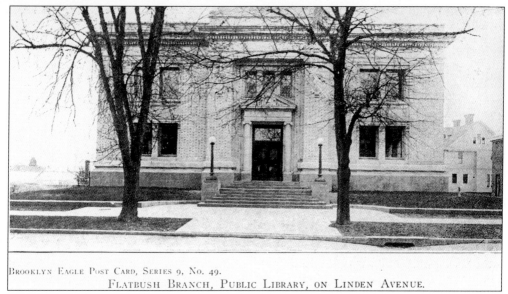

Flatbush Branch, Public Library, on Linden Avenue.

The opening of each of the Carnegie-funded branch libraries was hailed as a significant event in Brooklyn, and the *Eagle* listed a number of the openings among the major local happenings of 1905 in its year-end news summary. Included on the list was the opening of this building, the Flatbush Branch, located on the south side of Linden Avenue (now Linden Boulevard) just east of Flatbush Avenue, on October 7, 1905. The branch recently underwent significant renovations and continues to operate today.

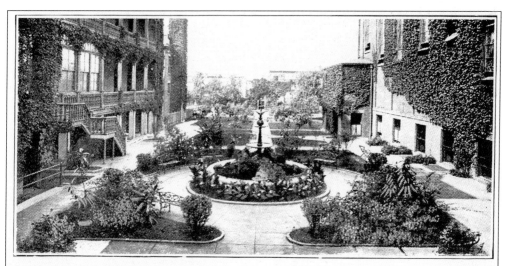

Gardens of the Convent of the Sisters of Mercy, cor. Classon and Willoughby Avenues.

The Convent of the Sisters of Mercy on the north side of Willoughby Avenue between Classon Avenue and Taaffe Place is yet another building designed by prolific Brooklyn ecclesiastical architect Patrick C. Keely. In 1905, the sisters operated an orphanage and industrial school for girls at this location. They also operated the Angel Guardian Home at 12th Avenue and 64th Street and another branch in Syosset, Long Island.

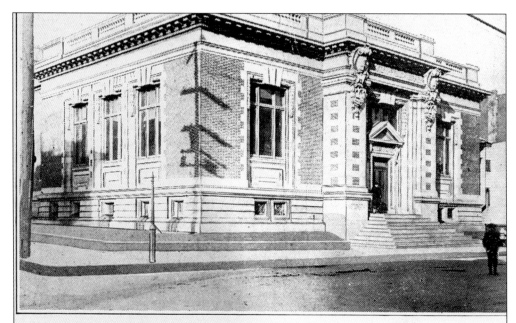

BROOKLYN EAGLE POST CARD, SERIES 31, No. 182.

GREENPOINT LIBRARY.

The Greenpoint Branch of the Brooklyn Public Library, on the northeast corner of Norman Avenue and Leonard Street, was another of the libraries that were built using funds provided by philanthropist Andrew Carnegie. It was brand new at the time this photograph was taken, with golden oak woodwork, brass trim, and potted palms in the reading rooms. The building was torn down and replaced by a new building on the same site, which opened in 1973.

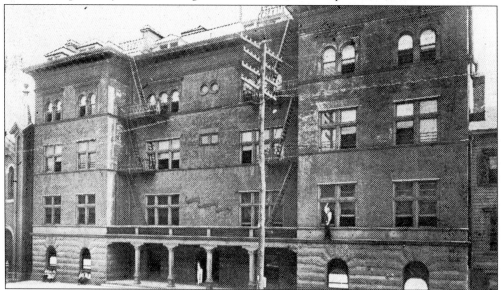

Cumberland Street Hospital and Training School for Nurses, on the east side of Cumberland Street between Park and Myrtle Avenues (a location now within Walt Whitman Houses, a large New York City public housing project), was founded in 1902 and operated by the Department of Public Charities for the sick poor.

86

Six
RECREATION AND
ENTERTAINMENT

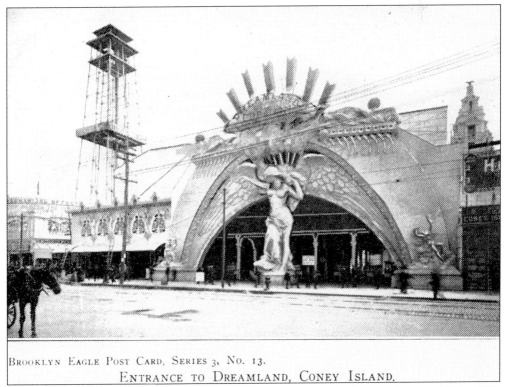

ENTRANCE TO DREAMLAND, CONEY ISLAND.

The 15-acre, grandiose Dreamland amusement park in Coney Island was only a year old in 1905. It reportedly had cost $3.5 million to build, a stupendous sum at that time. Just inside this entrance on Surf Avenue was an elaborate dramatization of the creation of the world. The park also featured a million light bulbs (at a time when electric lighting was still, for many, a novelty), chariot races, gondola rides, a miniature village inhabited by little people, and an exhibit of premature babies in incubators. Never as successful as its neighbor and competitor, Luna Park, it was destroyed in 1911 in a spectacular fire.

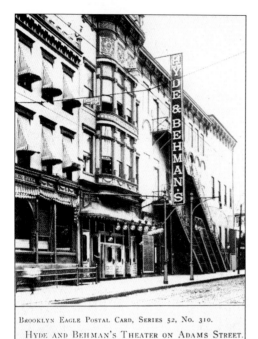

Hyde & Behman's Theater, which was located on the west side of Adams Street just south of Myrtle Avenue, had a seating capacity of 1,800. Like Brooklyn's other theaters during the era before motion pictures, it featured live performances. In 1905, the prices of admission ranged from 15¢ to $1.

BROOKLYN EAGLE POSTAL CARD, SERIES 52, No. 310.
HYDE AND BEHMAN'S THEATER ON ADAMS STREET.

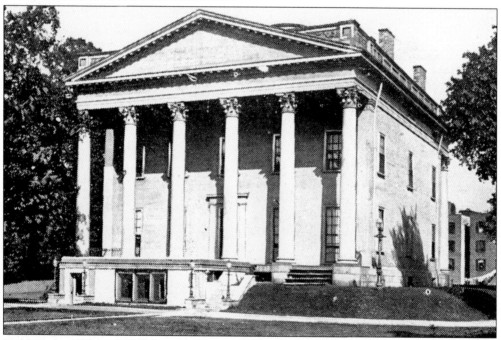

In 1905, the Midwood Club bought the former Matthew Clarkson mansion on the west side of East 21st Street just south of Caton Avenue, after renting it for a number of years. The club was a social organization made up primarily of prominent and well-heeled businessmen and professionals who had come to live in the large, newly built freestanding frame houses in Flatbush. The building dated from 1835. In its basement was the "log cabin room," a rustic meeting place filled with game heads, animal skins, and American Indian artifacts. The site of the club is now occupied by large apartment buildings.

The Crescent Athletic Club building, on the northwest corner of Clinton and Pierrepont Streets in Brooklyn Heights, had just been completed when this photograph was taken. It had squash courts, bowling alleys, a swimming pool, and a top-floor gymnasium, as well as a dining room, sleeping quarters, and a library. The building is now used by St. Ann's School.

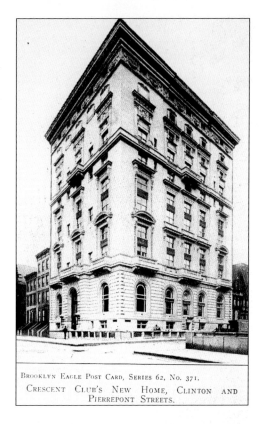

BROOKLYN EAGLE POST CARD, SERIES 62, No. 371.
CRESCENT CLUB'S NEW HOME, CLINTON AND PIERREPONT STREETS.

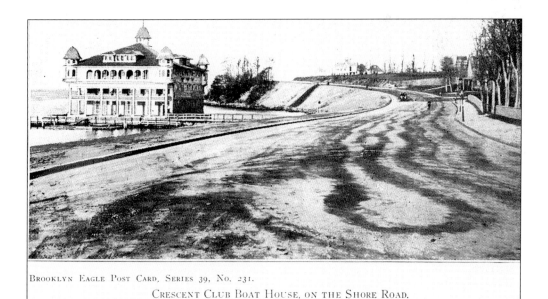

BROOKLYN EAGLE POST CARD, SERIES 39, No. 231.
CRESCENT CLUB BOAT HOUSE, ON THE SHORE ROAD.

In 1905, the Crescent Club was the largest athletic organization in Brooklyn. Founded in 1884, it had 2,000 members. The club owned a "country property," including athletic fields and this boathouse, between 83rd and 85th Streets at Shore Road in Bay Ridge.

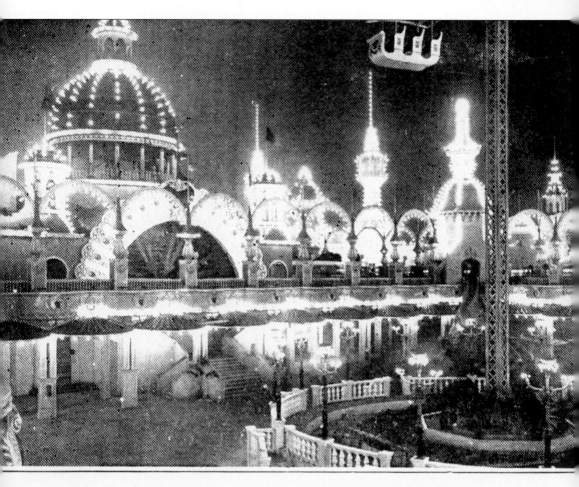

ROOKLYN EAGLE POST CARD, SERIES 13, NO. 77

LUNA PARK, CONEY ISLAND.

Luna Park was, like neighboring Dreamland and Steeplechase, an extravagant Coney Island amusement park. It was located on 22 acres between Neptune Avenue and Surf Avenue east of West 12th Street. It first opened in 1903 and included rides like the Trip to the Moon, the Shoot the Chutes (a water slide), and the Helter Skelter (a tortuous slide). It also featured a circus with performing elephants; a shop that sold dozens of different delicatessen items, like bolognas and hams, all made from candy; and spectacular illumination by electric lights at night, as shown here, all in an environment of exotic escapism. It continued to operate until 1946.

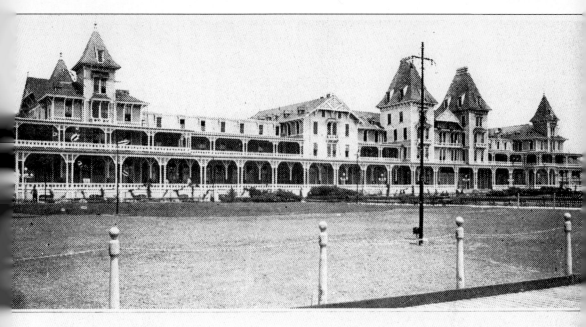

OKLYN EAGLE POST CARD, SERIES 34, No. 201.

BRIGHTON BEACH HOTEL.

The vast Brighton Beach Hotel faced the ocean at the southern end of Coney Island Avenue, east of the Coney Island Concourse. During the warm months, it offered concerts and access to horse racing at the Brighton Beach Race Course right behind it. In 1905, it charged $3 and up per night on the European plan (no meals included) and $4 and up on the American plan (meals included), which at the time was about three times the cost of a room at one of Brooklyn's downtown commercial hotels. This hotel was, amazingly, moved back 600 feet from the encroaching oceanfront using more than 100 railway flatcars in 1888.

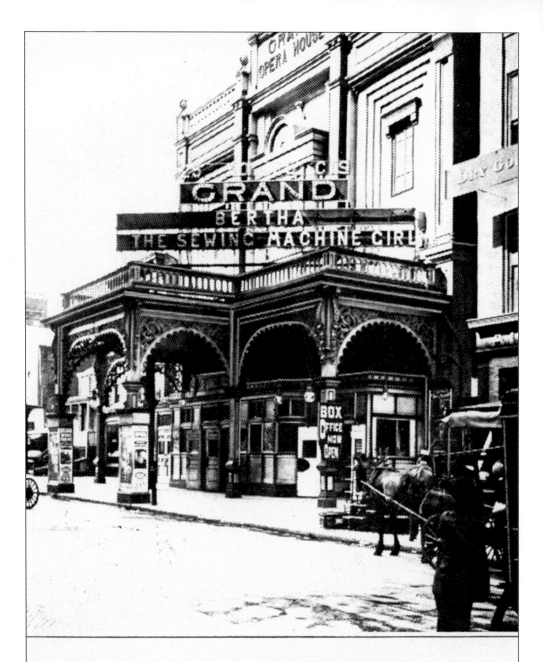

GRAND OPERA HOUSE, ELM PL., NEAR FULTON ST.

The Hyde & Behman Amusement Company's Grand Opera House, with a seating capacity of 2,300, stood on the west side of Elm Place, which runs for one block from Fulton Street to Livingston Street in Brooklyn's downtown shopping district. In 1905, admission ranged from 25¢ to $1, with a top price of 75¢ for Wednesday and Saturday matinees. When this photograph was taken, the play being presented was *Bertha the Sewing Machine Girl*. A parking facility now occupies the site.

The University Club of Brooklyn was housed in this mansard-roofed brownstone on the northeast corner of South Elliott Place and Hanson Place in the Fort Greene section. The club was founded in 1901. Its president in 1905 was Walter B. Gunnison, the principal of Erasmus Hall High School. The building is still standing today and is now a private residence.

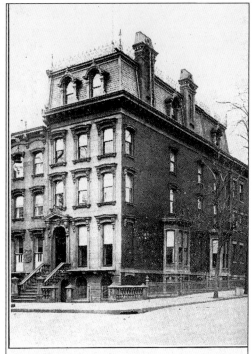

Brooklyn Eagle Post Card, Series 28, No. 166.
UNIVERSITY CLUB, ON SOUTH ELLIOTT PLACE.

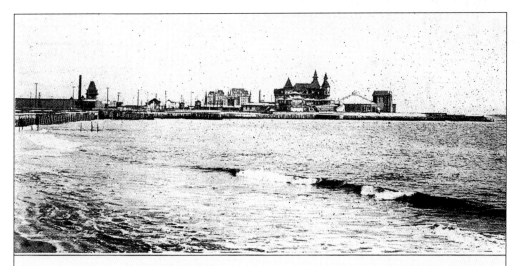

Brooklyn Eagle Post Card, Series 26, No. 154.
GENERAL VIEW OF MANHATTAN BEACH, AS SEEN FROM BRIGHTON.

The Manhattan Beach Hotel, in the center of this photograph, was located on the ocean approximately opposite the southern end of Ocean Avenue. The building with the light roof to the right of the towers was its music pavilion. This exclusive resort hotel offered concerts, plays, dining, and fireworks. In 1905, it charged $4 per night on the European plan (meals excluded). Its sister hotel to the east, the Oriental, charged $5 per night on the American plan (meals included) and catered to long-term guests.

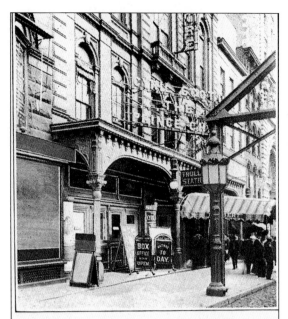

The Shubert Theatre, another establishment in downtown Brooklyn that presented live dramas in the days before motion pictures, was located on Fulton Street in the shadow of the elevated line opposite borough hall (still referred to as "City Hall" in this postcard, which was issued more than seven years after Brooklyn became a borough of New York City).

BROOKLYN EAGLE POSTAL CARD, SERIES 51, No. 305.
SHUBERT THEATRE, FULTON STREET, OPPOSITE CITY HALL

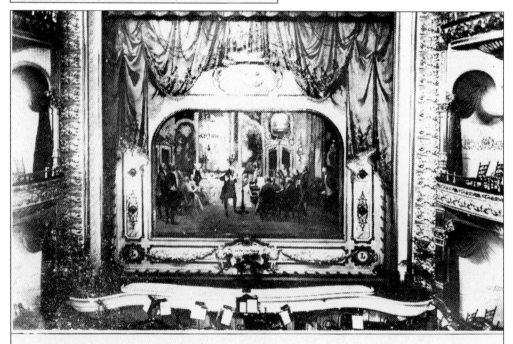

BROOKLYN EAGLE POST CARD, SERIES 69, No. 410.
PROSCENIUM ARCH OF THE BEAUTIFUL SHUBERT THEATRE

The Shubert was one of the smaller theaters of its type, with a seating capacity of 1,080, and its prices of admission were higher, ranging from 50¢ to $1.50. Its interior was lavishly decorated, as this photograph shows. In the days before amplification and widespread recording, any musical accompaniment would be provided by a live orchestra in the pit.

This unusual building was the clubhouse of the Benevolent and Protective Order of the Elks on the north side of Schermerhorn Street between Smith Street and Boerum Place. At the time, there were 1,745 Elks in Brooklyn, and they held meetings every Friday at this location. Note the life-size statue of the elk at street level. The entire block where the Elks' clubhouse stood is now occupied by a modern office building.

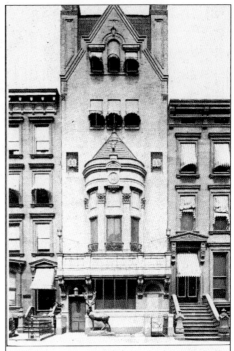

BROOKLYN EAGLE POST CARD, SERIES 57, NO. 339.

ELKS' CLUB HOUSE ON SCHERMERHORN STREET

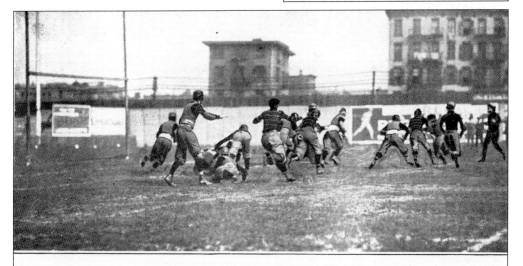

BROOKLYN EAGLE POST CARD, SERIES 3, NO. 17.

A PLAY NEAR THE GOAL LINE IN THE BOYS' HIGH SCHOOL-PRATT INSTITUTE
GAME AT WASHINGTON PARK.

The Washington Park Base Ball Grounds, which occupied two full blocks between Third and Fourth Avenues and First and Third Streets in South Brooklyn, was the home of the Brooklyn Base Ball Club in 1905. It should not be confused with Washington Park in Fort Greene, the city park that was later renamed Fort Greene Park, although "Washington Park" is preserved there as the name of the street that runs along the east side of the park.

95

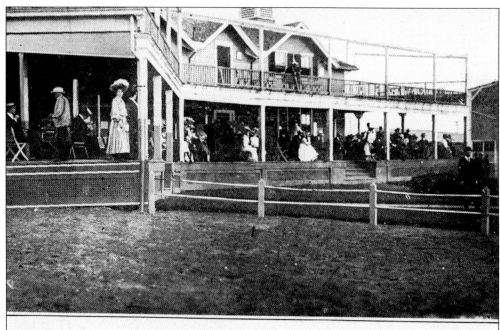

PARKWAY DRIVING CLUB HOUSE

The Parkway Driving Club occupied a large area along the west side of Ocean Parkway between Avenue P and Kings Highway, just north of the Brooklyn Jockey Club racetrack. At the time, there were two other racetracks in Brooklyn as well: the Brighton Beach Race Course behind the Brighton Beach Hotel and the largest, the Coney Island Jockey Club track east of Ocean Avenue and north of Voorhees Avenue in Sheepshead Bay.

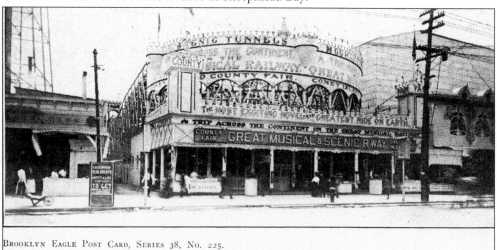

A CONEY ISLAND ATTRACTION.

The Coney Island attraction in this photograph is the Great Musical and Scenic Railway, billed as "the most exciting novel and greatest ride on earth." It was located on the south side of Surf Avenue at West Seventh Street, just west of the 300-foot observation tower, which had elevators that enabled sightseers to view Coney Island from far above street level. It can be seen at the left of the photograph, as well as in the view of Dreamland on page 87.

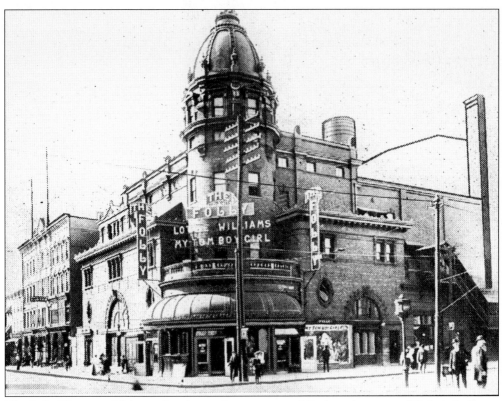

The Folly Theatre, which stood at the northwest corner of Graham Avenue and Debevoise Street in Williamsburg, down the street from Batterman's Department Store, had a seating capacity of 2,200. In 1905, it charged only 15¢ for its cheapest seats. The marquee in this photograph reads "Lottie Williams *My Tom Boy Girl*."

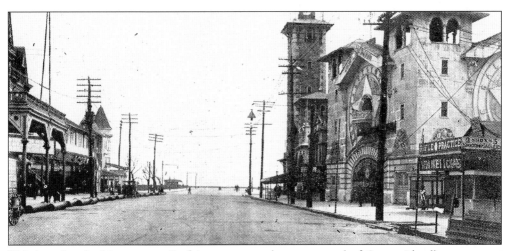

This is a view looking east on Surf Avenue, near the eastern end of Coney Island's amusement area. A shooting gallery (four shots for 5¢) is at the right. The building to the left of it was an attraction called the Galveston Flood, which used model buildings to simulate the destruction of Galveston, Texas, by a tidal wave.

LAKE IN INSTITUTE PARK.

Institute Park was formerly the name of the area that is now the Brooklyn Botanic Garden, behind the Brooklyn Institute of Arts and Science's Brooklyn Museum on Eastern Parkway. Although it was part of the property originally acquired for Prospect Park, it was separated from the rest of the property by Flatbush Avenue and was used as a dump for many years. During the two years before this photograph was taken, the man-made lake was created, trees and shrubs were planted, and hills were constructed.

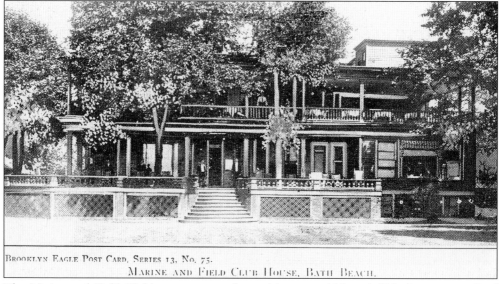

MARINE AND FIELD CLUB HOUSE, BATH BEACH.

The Marine and Field Club's property was located between 16th and 17th Avenues south of Cropsey Avenue, right on Gravesend Bay. Founded in 1885, this country club had 400 members in 1905. It offered golf and moorings for small boats.

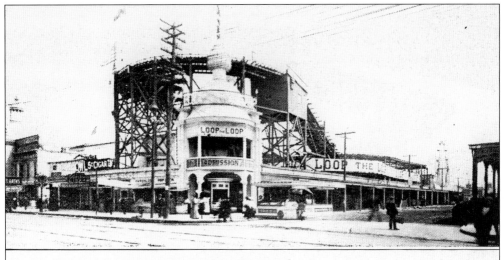

Brooklyn Eagle Post Card, Series 45, No. 269.

A Favorite Attraction at Coney Island.

This Coney Island attraction was the Loop the Loop, located on the south side of Surf Avenue across West 16th Street from Feltman's, whose proprietor reportedly invented the hot dog. The Loop the Loop was a roller coaster that included a section where the car suddenly ascended a steep incline and completed an upside-down and backwards elliptical loop. Visible in the background is the Dreamland tower.

Brooklyn Eagle Post Card, Series 19, No. 112.

Sunset Park.

In 1905, Sunset Park was a four-block, 14.25-acre city park located between 41st and 43rd Streets and 5th and 7th Avenues. It included this pond as well as tree-shaded pathways for quiet horse-and-buggy rides. It was later expanded to 44th Street and became the site of a public swimming pool.

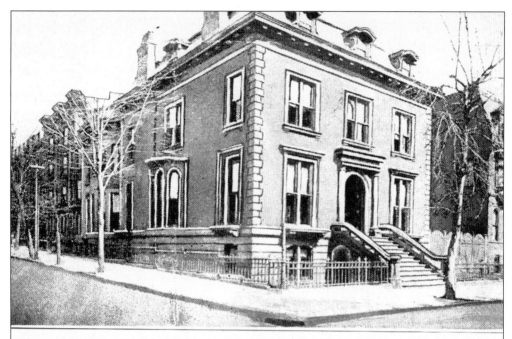

Brooklyn Eagle Post Card, Series 20, No. 120.

HANOVER CLUB, BEDFORD AVENUE AND RODNEY STREET.

The Hanover Club in Williamsburg was housed in this residential building, on the southeast corner of Bedford Avenue and Rodney Street, which was built *c.* 1875 and converted to club use in 1891. The club was founded in 1890; in 1905, it had 400 members. The building is in the heart of Williamsburg's Hasidic Jewish community and is now used by Young Israel of Brooklyn.

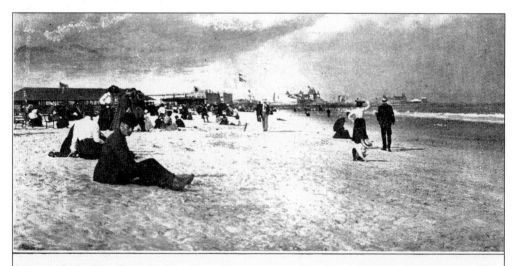

Brooklyn Eagle Post Card, Series 5, No. 25.

BEACH IN FRONT OF CONEY ISLAND PARK

This is a view looking east along the Coney Island beachfront on what appears to have been an overcast and windy day, at a time of year when no bathers braved the surf. The Brighton Beach and Manhattan Beach Hotels are visible in the distance.

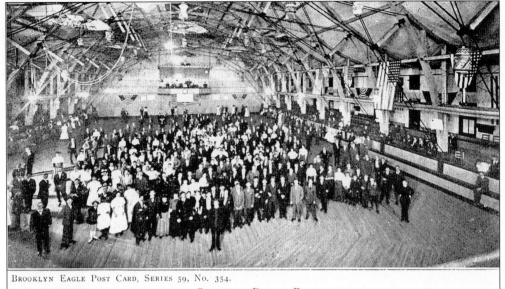

BROOKLYN EAGLE POST CARD, SERIES 59, No. 354.

CLERMONT ROLLER RINK.

The Clermont Roller Rink, on the east side of Clermont Avenue between Myrtle and Willoughby Avenues, was not used exclusively for roller-skating. During 1905, for example, the Pure Food Show and the bench show of the Long Island Kennel Club were also held there.

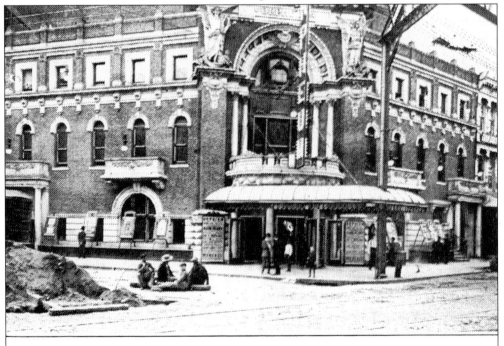

BROOKLYN EAGLE POST CARD, SERIES 79, No. 473.

THE ORPHEUM THEATRE, FULTON STREET AND ROCKWELL PLACE.

A popular downtown Brooklyn vaudeville theater was the Orpheum, which stood under the elevated line at the southwest corner of Fulton Street and Rockwell Place. It had a seating capacity of 1,800. Note the seated construction workers taking a lunch break in the foreground.

OOKLYN EAGLE POST CARD, SERIES 22, No. 127.

FORT GREENE PARK.

The 33-acre Fort Greene Park—originally called Washington Park and built on the site of a War of 1812 fortification named for Revolutionary War hero Nathaniel Greene—was redesigned beginning in 1867 by Frederick Law Olmsted and Calvert Vaux, who also designed Brooklyn's Prospect Park and Manhattan's Central Park. Their plan included a vault for the bones of American soldiers who had perished on British prison ships in nearby Wallabout Bay during the Revolution. An enormous granite Doric column, designed by the architectural firm of McKim, Mead & White as a monument to the prison ship martyrs, was erected in the park after this postcard was published. It was dedicated by president-elect William Howard Taft on November 14, 1908.

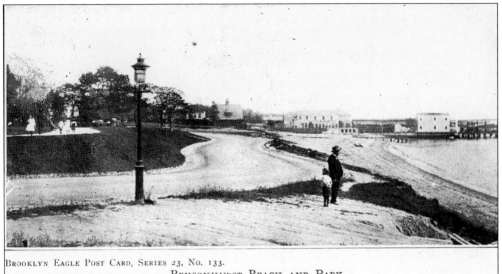

BENSONHURST BEACH AND PARK.

Bensonhurst Park was an eight-acre park south of Cropsey Avenue between 21st Avenue and Bay Parkway on Gravesend Bay. The Belt Parkway now cuts through the site.

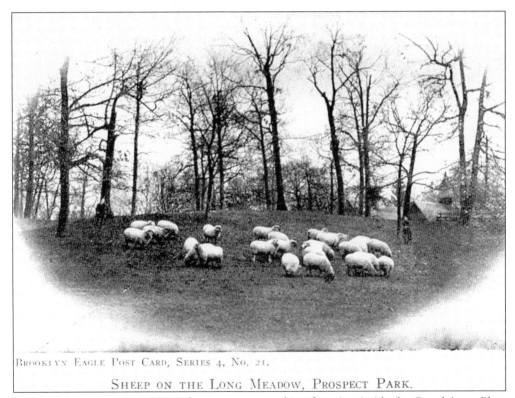

SHEEP ON THE LONG MEADOW, PROSPECT PARK.

Prospect Park's Long Meadow is the open area stretching from just inside the Grand Army Plaza entrance to the south and west about three-quarters of a mile, almost to present-day Prospect Park Southwest. In 1905, a flock of sheep grazed there.

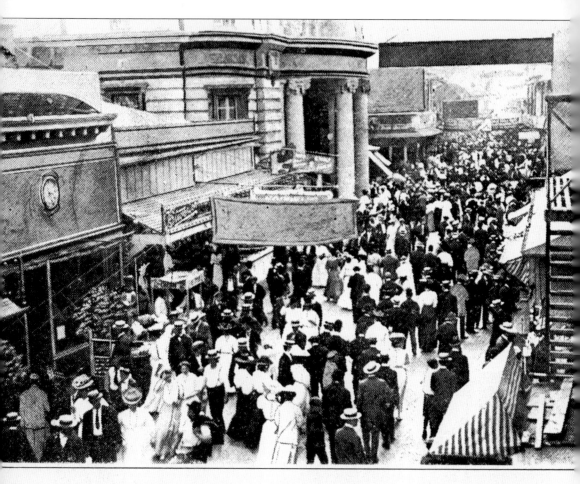

The Bowery—the narrow street south of Surf Avenue and parallel to it between Steeplechase Park at West 16th Street and Feltman's restaurant, beer garden, and carousel complex at West 11th Street—was Coney Island's teeming midway. It was lined with hot dog and corn stands, fortune-telling booths, shooting galleries, souvenir photographers' studios, dance halls, and saloons offering continuous musical entertainment and nickel beers.

Seven

RESIDENTIAL BROOKLYN

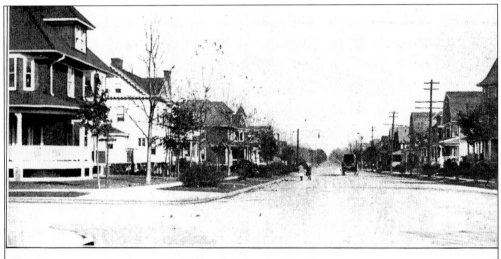

BROOKLYN EAGLE POST CARD, SERIES 46, NO. 274.

BEAUTIFUL BEVERLEY ROAD, FLATBUSH.

Most of the large houses in Flatbush, like these on Beverley Road, are so grand by today's standards that many people are surprised to learn that nearly all of them were built as developments. Typically, a developer would buy a large tract of farmland that belonged to a descendant of one of Flatbush's 17th-century Dutch settlers, lay out streets, and quickly erect a large number of new houses. One builder, the T. B. Ackerson Company, built several such developments in succession. Between Flatbush Avenue on the east and Coney Island Avenue on the west, beginning at Caton Avenue on the southern border of Prospect Park and continuing south to Avenue H, such developments included Prospect Park South, Beverley Square and Beverley Square West, Ditmas Park and Ditmas Park West, South Midwood, and Fiske Terrace.

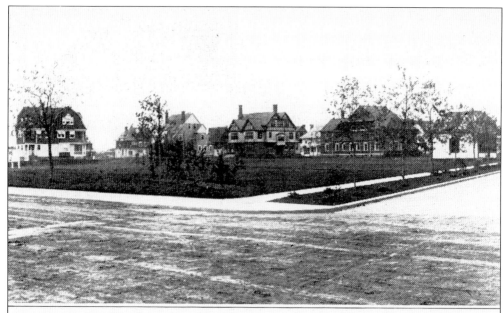

BEAUTIFUL DITMAS PARK

In contrast to the compact brick and masonry row houses of the older downtown Brooklyn neighborhoods, the houses being built in Flatbush in 1905 were typically spacious, freestanding, and constructed entirely of wood from the foundation up, like these homes in Ditmas Park.

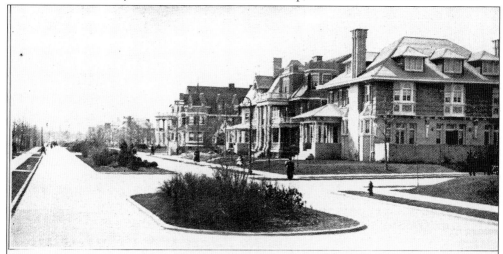

HANDSOME RESIDENCES ON ALBEMARLE ROAD, FLATBUSH.

The most prestigious Flatbush development was Prospect Park South, bounded by Church Avenue on the north, Beverley Road on the south, the Brighton Line tracks on the east, and Coney Island Avenue on the west. It dates from 1899 and includes a number of very large, unique, and architecturally significant houses. The grandest streets were Albemarle and Buckingham Roads, with planted malls. This photograph was taken from their intersection, looking west along Albemarle Road.

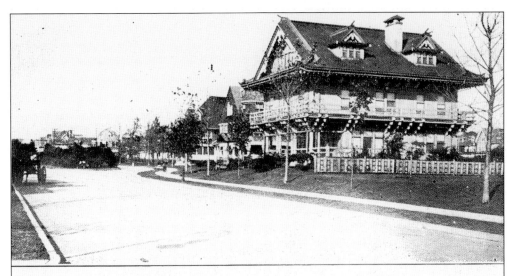

BROOKLYN EAGLE POST CARD, SERIES 4, No. 20.

UNIQUE JAPANESE HOUSE IN PROSPECT PARK SOUTH.

The novel "Japanese House," which still stands on the east side of Buckingham Road between Church Avenue and Albemarle Road, was built for Dr. Frederick S. Kolle, a German-born surgeon and pioneer in the field of x-rays. Artisans brought over from Japan reportedly were employed in its construction.

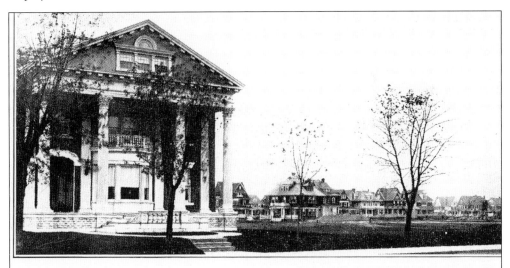

BROOKLYN EAGLE POST CARD, SERIES 7, No. 38.

SELECT RESIDENTIAL SECTION, DITMAS PARK.

This view of a "select residential section" in Ditmas Park is from Ocean Avenue just north of Newkirk Avenue, looking northwest. In the foreground, at the left, is the home of broker George W. Van Ness, whose father-in-law, builder Thomas H. Brush, lived in a nearly identical columned home immediately out of the photograph to the left. Within several years, real estate developer (and later Republican borough president) Lewis H. Pounds would fill in the entire open space shown with the large freestanding frame homes that now make up the Ditmas Park Historic District.

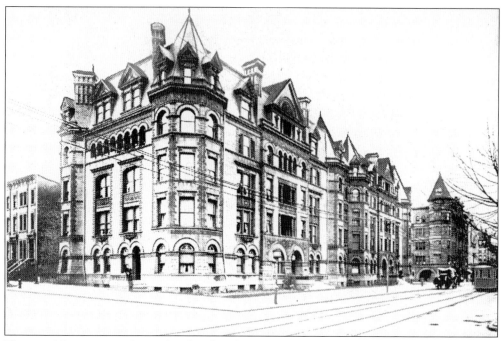

The grand Romanesque Revival-style Alhambra Apartment House, on the west side of Nostrand Avenue between Macon Street and Halsey Street in Bedford-Stuyvesant, is an enormous structure, a full city block long and five stories tall. It dates from *c.* 1890 and was designed by Montrose W. Morris, who was the architect of similar early apartment buildings and a number of opulent one-family residences in Bedford-Stuyvesant and Park Slope. The Alhambra has been restored in recent years to its former grandeur.

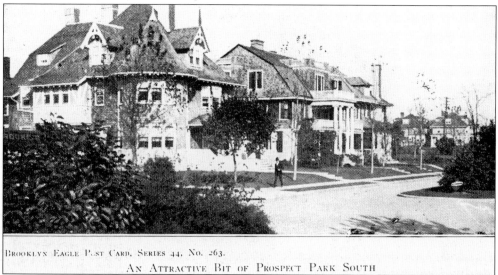

BROOKLYN EAGLE POST CARD, SERIES 44, No. 263.
AN ATTRACTIVE BIT OF PROSPECT PARK SOUTH

This view is from Rugby Road looking northeast at three majestic homes on the north side of Albemarle Road in the Prospect Park South section of Flatbush. All are on 66.8-foot-by-130-foot lots. The home at the left, 1505 Albemarle Road, belonged to Elmer A. Sperry, inventor of the gyrocompass, an airplane and ship stabilizer, and a high-intensity searchlight. Sperry held more than 400 patents and was president of the Sperry Gyroscope Company.

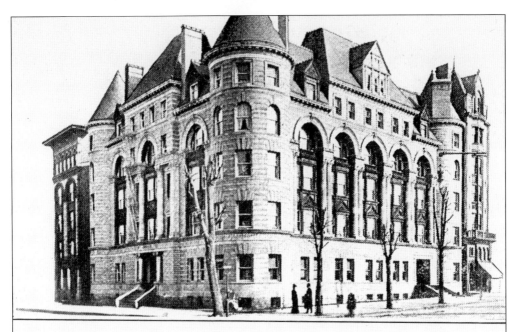

IMPERIAL APARTMENT HOUSE, BEDFORD AVENUE AND DEAN STREET.

The Imperial Apartment House on the southeast corner of Bedford Avenue and Pacific (not Dean) Street, which dates from *c.* 1892, is another early Brooklyn apartment building whose apartments offered the same level of spaciousness and elaborate detail as some of the finer single-family homes that were being built at about the same time. The building was also the work of architect Montrose W. Morris, who lived nearby in a house that he designed, located on Hancock Street between Nostrand and Marcy Avenues.

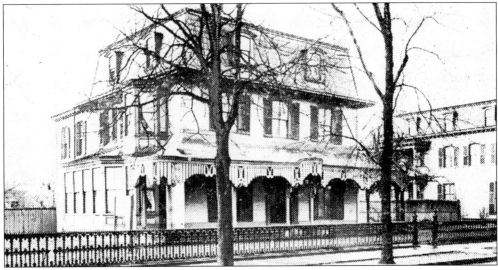

In 1905, when block upon block of row houses were the norm, these two mansard-roofed survivors of an earlier era on the southwest corner of Stuyvesant Avenue and Bainbridge Street in the Stuyvesant section stood out as old. Neither is still standing; limestone row houses now occupy the site.

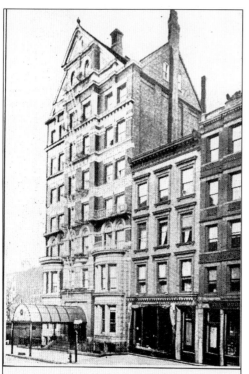

The Montague Apartment Hotel (105 Montague Street), on the north side of Montague Street between Hicks and Henry Streets, dates from *c.* 1885 and was designed by Parfitt Brothers. It originally contained two apartments and two servants' apartments per floor, with a top-floor room for tenants to use in entertaining. It still stands today.

BROOKLYN EAGLE POST CARD, SERIES 75, No. 446.
THE MONTAGUE APARTMENT HOTEL, MONTAGUE ST.

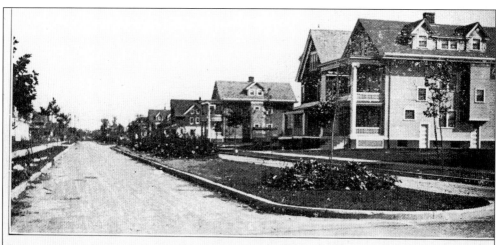

BROOKLYN EAGLE POST CARD, SERIES 77. No. 457.
AVENUE G, LOOKING EAST FROM CONEY ISLAND AVENUE.

This photograph was taken at Glenwood Road and Coney Island Avenue, looking east into the section of Flatbush now known as West Midwood. In 1905 and 1906, the T. B. Ackerson Company built massive two-family houses with front porches above and below, like the one in the foreground and those that line both sides of Westminster Road between Glenwood Road and Avenue H. Most of the other houses in West Midwood were built by the John R. Corbin Company, a pioneer in assembly-line construction, between 1904 and 1908.

110

The elaborately ornamented Beaux-Arts–style Mohawk Apartments building (379 Washington Avenue), on the east side of Washington Avenue between Greene and Lafayette Avenues, was brand new in 1905. Like other apartment buildings of that era, it was built on a comfortable scale, with high ceilings and spacious rooms. It was for many years a fashionable address in the Clinton Hill neighborhood and still stands today.

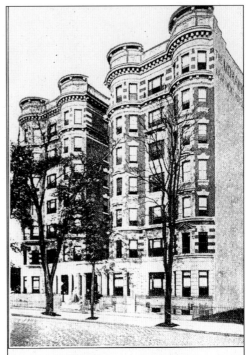

BROOKLYN EAGLE POST CARD, SERIES 67, No. 402.

THE MOHAWK APARTMENTS, WASHINGTON AVENUE, NEAR GREENE.

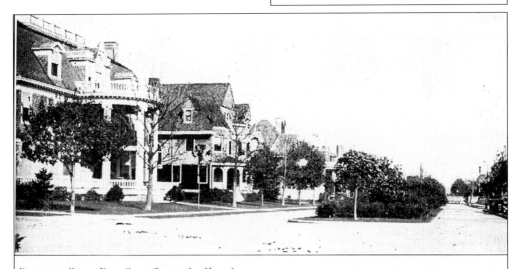

BROOKLYN EAGLE POST CARD, SERIES 62, No. 367.

BEAUTIFUL ALBEMARLE ROAD, PROSPECT PARK SOUTH.

This view, looking east along Albemarle Road from Rugby Road, shows at the left what was the largest house in Prospect Park South: 1409 Albemarle Road, which stood on a 133.4-foot-by-130-foot lot. It was the home of Frederick A. M. Burrell, who started out as a train dispatcher and agent on the Ninth Avenue Elevated Line in Manhattan and worked his way up to a senior position in the leather firm of Charles A. Schieren & Company. An apartment building now occupies the site.

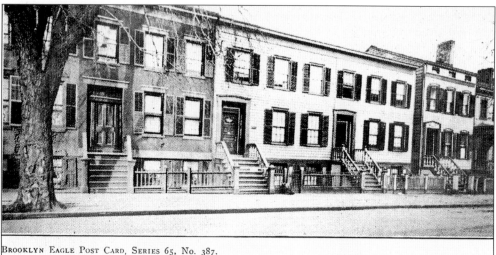

BROOKLYN EAGLE POST CARD, SERIES 65, No. 387.

TYPE OF VERY OLD HOUSES ON BALTIC STREET, NEAR SMITH.

This group of houses on the north side of Baltic Street between Court and Smith Streets was regarded, in 1905, as very old, although they are in many respects similar to the row houses that continued to be built in Brooklyn into the 20th century. These houses are still standing, although altered in appearance.

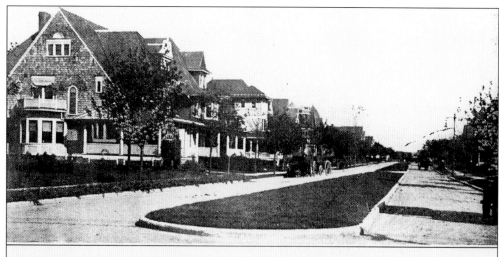

BROOKLYN EAGLE POST CARD, SERIES 61, No. 366.

BEAUTIFUL RESIDENTIAL SECTION OF FLATBUSH—AVENUE G, EAST OF OCEAN AVENUE.

In 1899, the Germania Real Estate and Improvement Company bought a large piece of the John A. Lott farm, extending all the way from Flatbush Avenue to Coney Island Avenue south of Foster Avenue. It immediately laid out streets, built curbs, planted trees, and began building large freestanding frame houses in the area east of Ocean Avenue. The development was called South Midwood (which can be confusing today because it is north of the larger area now known as Midwood). This is a view looking east along Glenwood Road from Ocean Avenue at the southwest corner of the development.

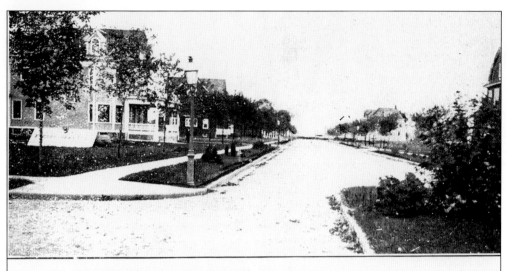

PRETTY SECTION OF MANHATTAN TERRACE.

Manhattan Terrace was another turn-of-the-20th-century development built on a tract of former farmland that had belonged to descendants of Brooklyn's early Dutch settlers, in this case the Van Nuyse family. It stretched from Avenue I south to Avenue M, and from the Brighton line train tracks (where there was a Manhattan Terrace stop) east to Ocean Avenue (where there was a community clubhouse).

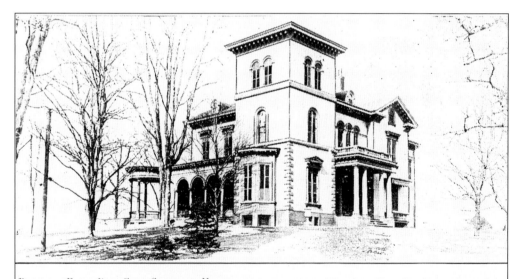

OWL'S HEAD, ON THE SHORE ROAD.

This Italianate mansion was one of many large homes with spectacular views of the Narrows that stood along Shore Road in Bay Ridge a century ago. Known as Owl's Head, it was located just north of 69th Street. It was originally the home of Henry Cruse Murphy, one of Brooklyn's most prominent citizens of the 19th century. Murphy was a lawyer, politician, diplomat, and scholar, as well as a founder of the *Eagle* and a champion of the construction of the Brooklyn Bridge. This was later the home of industrialist E. W. Bliss.

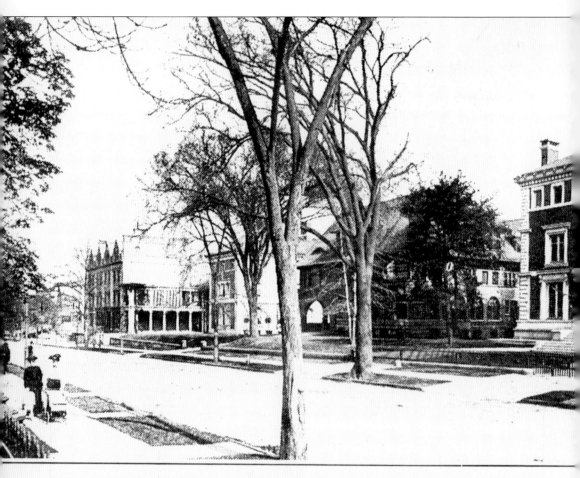

OOKLYN EAGLE POST CARD, SERIES 38, No. 226.

CLINTON AVENUE, BROOKLYN'S SHOW STREET.

This view of the east side of Clinton Avenue between DeKalb and Willoughby Avenues shows three mansions that belonged to members of the Pratt family. From right to left they are as follows: 245, the George DuPont Pratt house, which now belongs to Pratt Institute; 241, the Charles Millard Pratt house, which is now the residence of the Roman Catholic Bishop of Brooklyn; and 229, the Frederic B. Pratt house, which is now used by St. Joseph's College. Across the street at 232, and now also part of St. Joseph's College, is the former residence of the patriarch of the family, Charles Pratt, the paint and oil magnate who was associated with John D. Rockefeller and founded Pratt Institute in 1887.

Eight

EVERYDAY LIFE

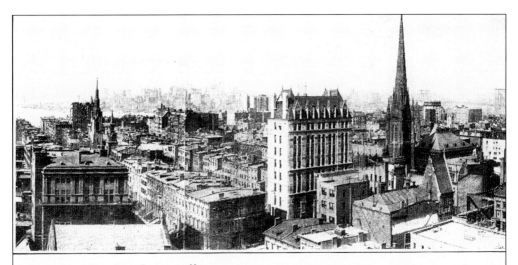

Brooklyn Eagle Post Card, Series 17, No. 97.

VIEW OF BROOKLYN, LOOKING TOWARDS THE BROOKLYN BRIDGE—HOLY TRINITY
CHURCH IN THE FOREGROUND.

This is a view from the rear of the Temple Bar Building on Court Street, looking northwest across Brooklyn Heights, past the Franklin Trust Company building and Holy Trinity Episcopal Church, and toward the towers of the Brooklyn Bridge, which are visible at the right. The sandstone, Gothic-style Holy Trinity, which dates from 1847 and still stands on the northwest corner of Clinton and Montague Streets, was designed by Minard Lafever and paid for entirely by contributions from one man: paper manufacturer Edgar John Bartow.

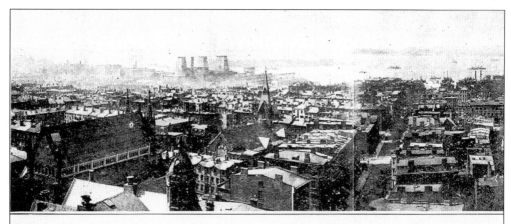

Brooklyn Heights and New York Harbor.

This view was most likely also taken from the rear of the Temple Bar Building at Court and Joralemon Streets, looking southwest. The tower of Packer Collegiate Institute is in the foreground, St. Ann's Episcopal Church on Clinton Street is in the lower left corner, the New York Dock Company's grain elevators at the foot of Atlantic Avenue and Pacific Street are visible along the waterfront in the center, and Governor's Island appears in the distance just right of center.

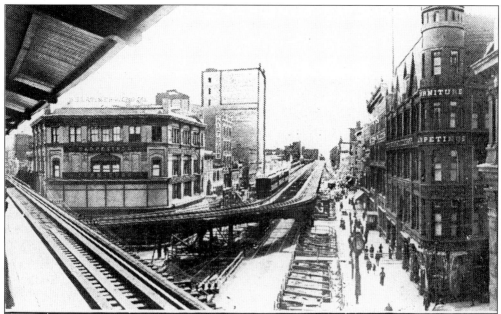

Junction of Flatbush Avenue and Fulton Street.

This photograph of Flatbush Avenue, looking south from the Fulton Street elevated platform, shows a train approaching with the Pioneer Warehouses building behind it. The building in the foreground at the left housed B. G. Latimer & Sons Company, and the building with the tower at the right, at the corner of Nevins Street, housed the Cowperthwait Company. Both sold carpeting and furniture.

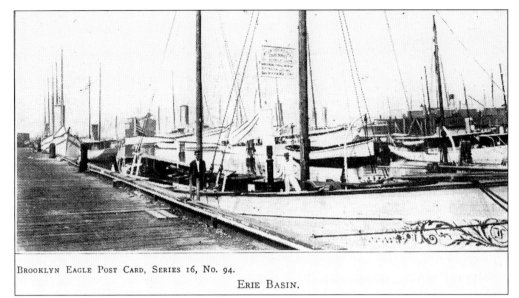

BROOKLYN EAGLE POST CARD, SERIES 16, No. 94.

ERIE BASIN.

Erie Basin is an inlet almost fully enclosed by a mile-long breakwater at the southern end of Red Hook, stretching from the foot of Van Brunt Street east to the foot of Columbia Street. In 1905, it was 161 acres in size and contained piers, elevators, storage warehouses, and large dry docks. It provided winter dockage for hundreds of canal boats; the crews and their families would remain on board. It was also the home of Manning's Yacht Agency, which serviced hundreds of yachts.

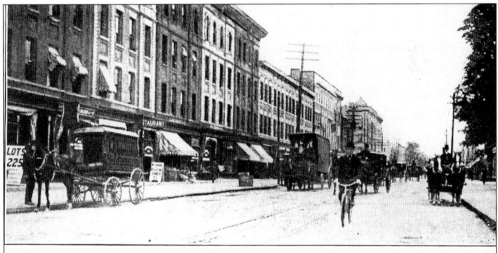

BROOKLYN EAGLE POST CARD, SERIES 12, No. 70.

FLATBUSH AVE. AT LINDEN AVE., EAGLE FLATBUSH BRANCH ON THE LEFT.

When this photograph was taken on Flatbush Avenue just south of Linden Avenue (now Linden Boulevard), looking north, there was only horse-and-wagon and bicycle traffic on this busy thoroughfare. The Flatbush office of the *Eagle* was located in a storefront at the left. Note the awnings on both the shops and the windows of the apartments above them and the sign offering building lots for $225.

This view up Fulton Street to the east was very likely taken from the front of the Temple Bar Building at Court and Joralemon Streets. The tower of borough hall is at the left in the foreground. The dome of the old county courthouse and the top of the old municipal building (both of which are now gone) are at the right. The tall structure just to the right of Fulton Street in the distance is the Fulton & Flatbush Storage Company clock tower on Nevins Street, which is also now gone.

The Diocesan Union of Holy Name Societies in Brooklyn, founded in 1878, held its meetings quarterly at St. Joseph's Roman Catholic Church Hall on Dean Street near Vanderbilt Avenue. In this photograph, most likely taken from the Soldiers' and Sailors' Arch at Grand Army Plaza, the membership is shown marching on Eastern Parkway. The towers of St. Teresa's Church at Classon Avenue and Sterling Place are visible in the distance.

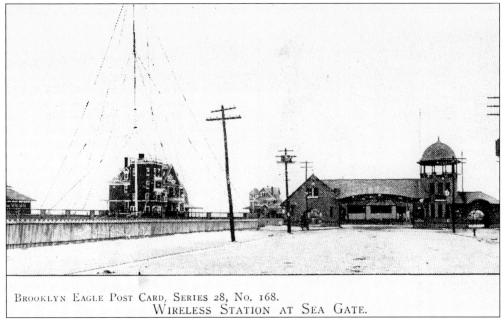

Brooklyn Eagle Post Card, Series 28, No. 168.
WIRELESS STATION AT SEA GATE.

When Guglielmo Marconi discovered how to transmit wireless messages, one of the first telegraph stations established in the United States was at Sea Gate, the private community at the western end of Coney Island. David Sarnoff, many years later the president and chief executive officer of RCA, was reportedly a wireless operator here as a young man.

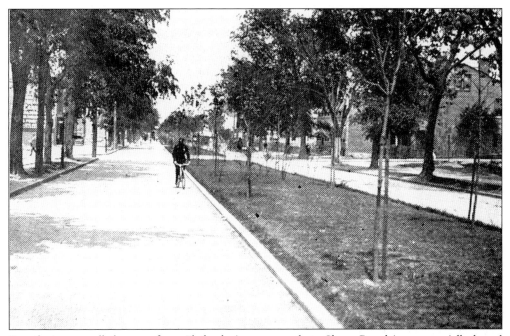

Fourth Avenue all the way from Flatbush Avenue south to Shore Road is an especially broad street—100 feet wide—and, in 1905, had planted malls along most of its length. In the days before widespread use of automobiles, traffic was light in this more sparsely populated stretch, and policemen, like the one in this photograph, patrolled on bicycle.

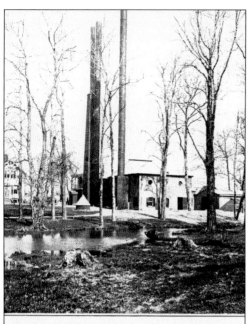

In 1905, most of Brooklyn's water was obtained from streams and wells in Long Island and conducted by pipes and conduits to a main pumping station in Ridgewood, where it was passed into distribution mains. The Flatbush Water Works, however, was a private company located at the head of Paerdegat Creek at present-day Foster Avenue and East 32nd Street. It supplied well water to the 29th Ward, corresponding roughly to the present-day Flatbush neighborhood.

BROOKLYN EAGLE POST CARD, SERIES 26, No. 156.
FLATBUSH WATER-WORKS.

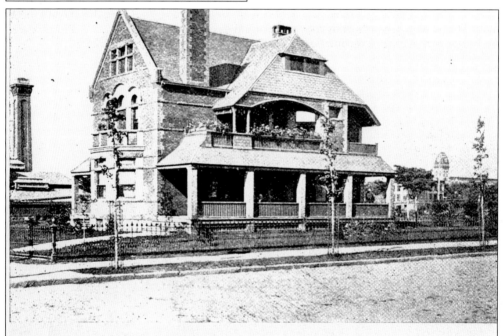

BROOKLYN EAGLE POST CARD, SERIES 78, No. 466.
MT. PROSPECT PUMPING STATION.

There was also a reservoir at Mount Prospect on the south side of Eastern Parkway between Grand Army Plaza and the Brooklyn Museum, into which water was pumped from Ridgewood. This reservoir was the source of water for the surrounding neighborhood. Associated with it were a landmark water tower (visible in the next photograph) and this pumping station.

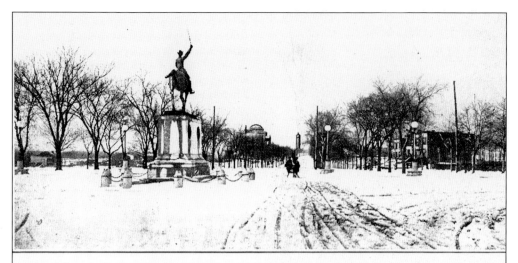

EASTERN PARKWAY FROM PROSPECT PARK TO HIGHLAND PARK.

This view along Eastern Parkway is looking west rather than east, with the Brooklyn Museum and the Mount Prospect water tower near Flatbush Avenue in the distance. It shows the rear of the equestrian statue of Civil War general Henry Warner Slocum by Frederick W. MacMonnies, which stood at Bedford Avenue. When the statue was dedicated on May 30, 1905, Pres. Theodore Roosevelt was present to make an address. He was then entertained at the nearby Union League Club. The statue was subsequently moved twice and is now in a small raised and fenced park area on the northeast corner of the intersection of Flatbush Avenue and Eastern Parkway.

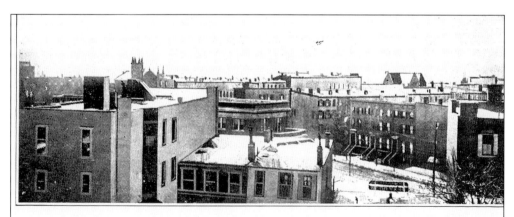

LOOKING TOWARD HEYWARD ST. AND BEDFORD AVE. FROM BROADWAY AND MARCY AVE.

This photograph, looking south across rooftops in the Williamsburg section, was taken from the Marcy Avenue elevated station platform. The building partially visible in the center is the Williamsburg Branch of the Brooklyn Public Library.

121

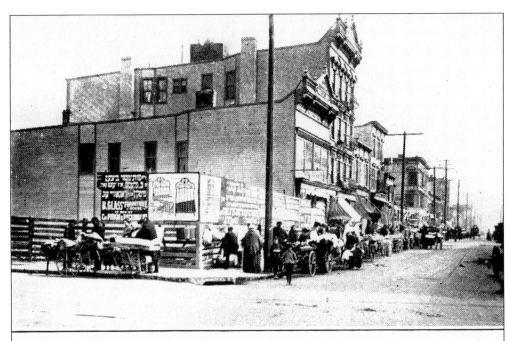

BROOKLYN EAGLE POST CARD, SERIES 25, NO. 145.
A BROWNSVILLE STREET SCENE—LOOKING UP BELMONT AVENUE TOWARD
POWELL STREET.

In 1859, a Manhattan broker named Charles L. Brown bought a large tract of farmland in the Town of New Lots, laid out streets, and built a small community of houses that became known as Brownsville. After the Williamsburg Bridge opened, Brownsville was linked by public transportation with Manhattan, and a rapid influx of Jews from the crowded Lower East Side followed. In this busy street scene, note the advertisement at the left in both Hebrew and English.

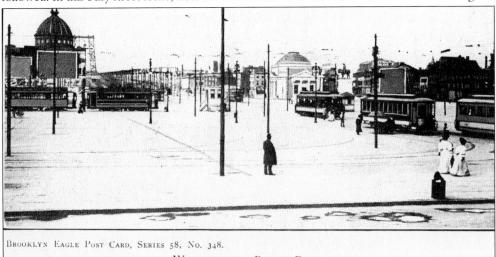

BROOKLYN EAGLE POST CARD, SERIES 58, NO. 348.
WILLIAMSBURG BRIDGE PLAZA.

This view of the plaza on the Brooklyn side of the recently opened Williamsburg Bridge shows the original Williamsburg Savings Bank building at the left and the dome of the newly constructed Williamsburg Trust Company building on the right. Trolley cars began running across the bridge in 1904.

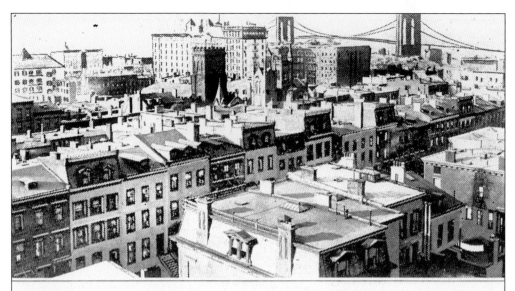

VIEW OF THE HEIGHTS FROM THE EAGLE TOWER.

This view, looking northwest from the tower of the Brooklyn Daily Eagle building at Washington and Johnson Streets, shows the tower of the First Presbyterian Church on Henry Street in the center, with the St. George Hotel behind it and the Brooklyn Bridge to its right.

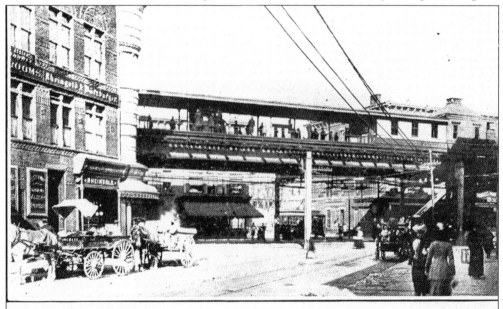

GATES AVENUE LOOKING TOWARDS BROADWAY.

This view, looking east on Gates Avenue toward Broadway, shows passengers waiting for a train on the Gates Avenue station platform of the Broadway elevated line. From this station, one could take either a train that ran all the way along Broadway to the Williamsburg Bridge or a train that turned west on Lexington Avenue and continued on elevated tracks via Lexington Avenue and Grand Avenue to downtown Brooklyn.

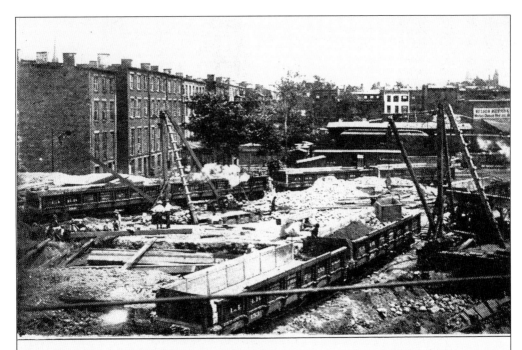

BROOKLYN EAGLE POST CARD, SERIES 1, No. 5.
EXCAVATING FOR THE NEW LONG ISLAND RAILROAD STATION.

This view shows construction under way for the Long Island Railroad's Flatbush Avenue terminal, which stood for many years at the southeast corner of Flatbush Avenue and Hanson Place. The station's opening on April 1, 1907, coincided with a rare late blizzard that left Brooklyn under more than six inches of snow.

BROOKLYN EAGLE POST CARD, SERIES 55, No. 330.
BROOKLYN TERMINAL OF 39TH STREET FERRY.

The New York and South Brooklyn Ferry and Steam Transportation Company ran a ferry from this terminal at the foot of 39th Street to the battery at the southern tip of Manhattan. In 1905, it was one of 14 ferries that operated between the two boroughs.

124

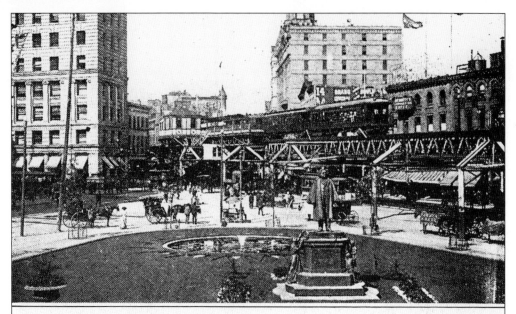

BROOKLYN EAGLE POST CARD, SERIES 37, No. 219.
JUNCTION OF COURT, FULTON AND WASHINGTON STREETS.

This view from borough hall looking north shows the Henry Ward Beecher statue in the foreground, the Fulton Street elevated line with a train on it heading southeast, and the Brooklyn Daily Eagle building looming in the distance. The entire center section of the scene stretching several blocks northward is now occupied by Cadman Plaza.

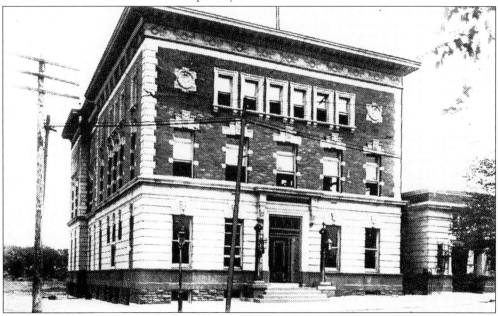

The 71st Precinct police station stood at the northeast corner of 86th Street and 5th Avenue in Bay Ridge. In 1905, the precinct had a force of 53 and covered the entire area south of the Sea Beach train tracks (along 62nd Street) and west of 13th Avenue. At the time, a patrolman was paid from $800 to $1,400 per year.

OOKLYN EAGLE POST CARD, SERIES 32, NO. 189.

GOWANUS CANAL BELOW FIFTEENTH STREET.

The murky Gowanus Canal—the narrow, zigzagging body of water that cuts north from Gowanus Bay at the eastern edge of Red Hook for more than a mile before dead-ending between Douglass and Butler Streets—was for many years the subject of jokes about stench and pollution. A new bridge across the canal at Hamilton Avenue opened on March 4, 1905.

ROOKLYN EAGLE POST CARD, SERIES 24, NO. 142.

MANHATTAN AVENUE, LOOKING SOUTH FROM GREENPOINT AVENUE.

This view shows a large number of people out strolling on the sidewalks, just as you often find today in the commercial stretch of the Greenpoint neighborhood. The location was incorrectly identified, however; the view is actually looking north on Manhattan Avenue from Milton Street toward the intersection with Greenpoint Avenue, where the flagpole stood.

BIBLIOGRAPHY

Armbruster, Eugene L. *Brooklyn's Eastern District*. Brooklyn: published by the author, 1941.

Boughton, Willis and Eugene W. Harter. *Chronicles of Erasmus Hall*. Brooklyn: General Organization of Erasmus Hall High School, 1906.

Brooklyn Daily Eagle Almanac. Brooklyn: Brooklyn Daily Eagle, 1886–1929.

Connolly, Harold X. *A Ghetto Grows in Brooklyn*. New York: New York University Press, 1977.

Fisher, Edmund D. *Flatbush Past & Present*. Brooklyn: Flatbush Trust Company, 1901.

Gunnison, Herbert F., ed. *Flatbush of To-day*. Brooklyn: All Souls Universalist Church, 1908.

King, Moses. *King's Views of New York, 1896-1915 & Brooklyn, 1905*. New York: Arno Press, 1977.

Lancaster, Clay. *Old Brooklyn Heights*. Rutland, Vermont, and Tokyo: Charles E. Tuttle Company, 1961.

Lancaster, Clay. *Prospect Park Handbook*. New York: Walter H. Rawls, 1967.

Landesman, Alter F. *Brownsville: The Birth, Development and Passing of a Jewish Community in New York*. New York: Bloch Publishing Company, 1969.

Landesman, Alter F. *A History of New Lots, Brooklyn*. Port Washington, New York: Kennikat Press, 1977.

McCullough, Edo. *Good Old Coney Island*. New York: Charles Scribner's Sons, 1957.

Morrone, Francis. *An Architectural Guide to Brooklyn*. Salt Lake City, Utah: Gibbs–Smith Publishers, 2001.

Murphy, Mary Ellen and Mark, and Ralph Foster Weld, eds. *A Treasury of Brooklyn*. New York: William Sloane Associates, 1949.

Nickerson, Marjorie L. *A Long Way Forward: The First Hundred Years of the Packer Collegiate Institute*. Brooklyn: Packer Collegiate Institute, 1945.

Osterland, Alfred, comp. *Good Old East New York*. Brooklyn: The East New York Savings Bank, 1943.

Richman, Jeffrey I. *Brooklyn's Green-Wood Cemetery*. Brooklyn: The Green-Wood Cemetery, 1998.

Schroth, Raymond A., S.J. *The Eagle and Brooklyn: A Community Newspaper, 1841-1955*. Westport, Connecticut: Greenwood Press, 1974.

Sharp, John K. *History of the Diocese of Brooklyn, 1853-1953*. New York: Fordham University Press, 1954.

Snow, Richard. *Coney Island: A Postcard Journey to the City of Fire*. New York: Brightwaters Press, 1984.

Souvenir of our Public Schools, Brooklyn, New York. Brooklyn: E. J. Whitlock, 1892.

Stiles, Henry R., ed. *The Civil, Political, Professional and Ecclesiastical History and Commercial and Industrial Record of the County of Kings and the City of Brooklyn, N.Y. from 1683 to 1884*. New York: W. W. Munsell & Company, 1884.

Warriner, Edwin. *Old Sands Street Methodist Episcopal Church of Brooklyn, N.Y.* New York: Phillips & Hunt, 1885.

White, Norval, and Elliot Willensky. *AIA Guide to New York City*. 4th ed. New York: Three Rivers Press, 2000.